The Campus History Series

MARSHALL UNIVERSITY

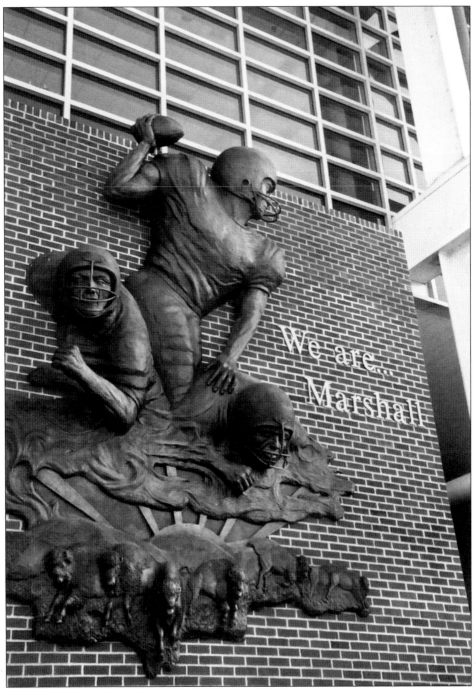

This massive bronze sculpture on the wall at Marshall's Joan C. Edwards Stadium is dedicated to the victims of the 1970 jet crash. The 17-by-23-foot sculpture by artist Burl Jones cost $150,000, all of which was raised by Marshall fans.

On the Cover: Jubilant Marshall students celebrate the 1961 announcement that the West Virginia Legislature has granted Marshall university status.

The Campus History Series

MARSHALL UNIVERSITY

James E. Casto

Published by Arcadia Publishing
Charleston SC, Chicago IL, Portsmouth NH, San Francisco CA

Printed in Great Britain

Library of Congress Catalog Card Number: 2005929133

For all general information contact Arcadia Publishing at:
Telephone 843-853-2070
Fax 843-853-0044
E-mail sales@arcadiapublishing.com
For customer service and orders:
Toll-Free 1-888-313-2665

Visit us on the internet at http://www.arcadiapublishing.com

CONTENTS

ACKNOWLEDGMENTS

Think of the hours of enjoyment derived from rummaging through old photographs of your family and friends. That kind of happy experience is the goal of this collection of vintage photographs chronicling the story of the "Marshall family." This is not an encyclopedic account of Marshall's history. That would require a volume far larger than this thin paperback. Instead it is simply a Marshall scrapbook, offering a deliberately wide-ranging variety of scenes, some of them significant, others included just for fun.

A book such as this depends a great deal on the work of those who have gone before. In researching the photographs included here, two books were always within my reach: *Marshall University: An Institution Comes of Age* (1981) by legendary Marshall history professor Charles H. Moffat and *Marshall Memories* (1986) by veteran Marshall journalism professor Ralph J. Turner. I am in their debt.

Most of the photographs herein come from Marshall's archives. Some few are from *The Herald-Dispatch*, *Huntington Quarterly*, and my personal collection. Marshall's library staff has gone not just the second mile but the third mile as well in aiding me in compiling this book. I wish to thank Dean of Libraries Barbara Winters, Special Collections Curator Lisle Brown, archivist Cora Teel, and digital media technician Andrew Earles.

Finally, I would be sadly remiss if I did not salute the many photographers, both known and unknown, whose handiwork is included here. All of us who love Marshall owe them a vote of thanks for their efforts.

INTRODUCTION

Named for John Marshall, the great chief justice of the U.S. Supreme Court, Marshall University traces its roots to 1837, when residents of the village of Guyandotte and the surrounding area—then still a part of Virginia—determined that their sons and daughters needed a school. The new school first met at a log cabin known as Mount Hebron Church. Located on a wooded hilltop called Maple Grove, the church overlooked Holderby's Landing, an Ohio River wharf built and operated by the Holderby family to serve the needs of their farm and other nearby residents. Tradition has it that local lawyer John Laidley convinced his neighbors to name the school for his friend Marshall, and on March 20, 1838, the Virginia General Assembly formally chartered Marshall Academy.

Usually little more than a step away from bankruptcy, the struggling school nonetheless somehow managed to survive, and in 1858, it was designated Marshall College. The turmoil of the Civil War forced the school's closure, and in 1863, Laidley's daughter, Salina C. Mason, bought the property for $1,500. Four years later, the new state of West Virginia, which had broken away from Virginia, agreed to buy back the school—paying Mrs. Mason $3,600—and designated it to train teachers.

In 1869, rail tycoon Collis P. Huntington arrived on the scene, purchasing a vast stretch of land along the Ohio just downstream from Guyandotte—a tract that included Holderby's Landing—as the western terminus of his Chesapeake & Ohio Railway and the site of a new town. On February 27, 1871, the West Virginia Legislature approved an act incorporating the city of Huntington, named for its founder. In the more than 130 years since, the histories of Huntington and Marshall have been inextricably intertwined.

While the new city of Huntington immediately grew and prospered, Marshall more or less languished until the tenure of Lawrence J. Corbly, who was named the school's first president in 1896. Until then, the school's chief administrators had carried the title of principal. Serving as president until 1915, Corbly undertook a number of initiatives that essentially transformed Marshall from a preparatory school into a true college.

Over the years, Mount Hebron Church gave way to a series of structures that, eventually joined together, became known as Old Main, which continues today as Marshall's administrative center and its best-known landmark. It was not until 1916, and the construction of Northcott Hall, that Marshall became a two-building campus. The construction of other structures followed, including a girls' gym in the 1921–1922 school year, Fairfield Stadium in 1928, the James E. Morrow Library in 1931, and the Shawkey Student Union in 1933. All these, save Old Main and the Morrow Library, have since fallen before the wrecker's ball.

The College of Education, first called Teachers College, was organized in 1920, and the first four-year degree was awarded in 1921. The College of Arts and Sciences was formed in 1924. James E. Allen became president in 1935, succeeding Morris P. Shawkey, who had served 12 years.

Marshall struggled during the Great Depression, but in 1937, it optimistically celebrated its centennial. It addition to a crowded calendar of anniversary events, the Marshall Artists Series was established and several new buildings built, including Hodges and Laidley dormitories and the Jenkins Laboratory School. In 1938, the state authorized Marshall to offer its first master's degrees.

Like the rest of America, Marshall had to put its dreams on hold during the World War II years, but the war unexpectedly set the stage for the school's greatest growth ever, as hundreds of returning veterans used their Montgomery G.I. Bill benefits to enroll. School officials were hard-pressed to come up with space to accommodate the returning vets. Housing was especially difficult, as many of the new students were married with families.

Stewart H. Smith, dean of the Teachers College, became president in 1946 and led the school until 1968. The Graduate School was created in 1948. The men's basketball team was a national championship in 1947, and the football team played in the 1948 Tangerine Bowl. Both teams were coached by the legendary Cam Henderson. Campus construction included a new science building, dedicated in 1950.

Marshall gained university status in 1961, ushering in a period of undreamed-of expansion. Campus construction in the 1960s included a new men's physical education facility, a major classroom building and adjoining music hall, four new residence halls, the Campus Christian Center, a major addition to the library, and a renovation of Fairfield Stadium. The men's basketball teams played in national tournaments and the football team ended the nation's longest losing streak. However, Marshall was suspended by the Mid-American Conference and placed on probation by the NCAA for recruiting violations.

The campus and community were plunged into tragedy on November 14, 1970, when a chartered jetliner crashed at Huntington's Tri-State Airport, killing all 75 people aboard—Marshall football players, coaches, fans, and the aircraft's crew. In the wake of the tragedy, some urged that Marshall give up football, but the school persevered and built a program that didn't just survive but earned national recognition. A new student center and a handsome fountain memorialized the victims of the crash.

Robert B. Hayes, dean of the Teachers College, became president in 1974 and would serve for nine eventful years. The Community College was created in 1975, and the School of Medicine admitted its first class in 1978. Dale F. Nitzschke became the school's 11th president in 1984.

In 1981, Marshall basketball finally got an on-campus arena with the opening of Henderson Center. A decade later, in 1991, Marshall hosted the first game in its impressive new football stadium.

A new state-of-the-art library, a spectacular performing arts center, a $40-million biotechnology center, and other recent additions to the historic Huntington campus help guarantee that Marshall, with its roots deep in the 19th century, is extending its reach well into the 21st century.

One

FROM ACADEMY TO COLLEGE

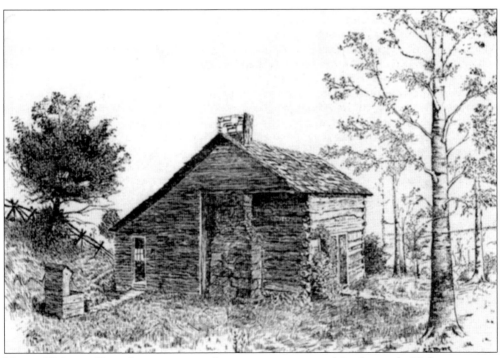

Mount Hebron Church, a one-room log structure erected in the early 19th century at a site known as Maple Grove, served several denominations and, in 1837, became the home of the fledgling Marshall Academy. It is not known what the church looked like, as no image of it has come down to us, but it must have looked very much like this, a typical cabin on the Virginia frontier of that day.

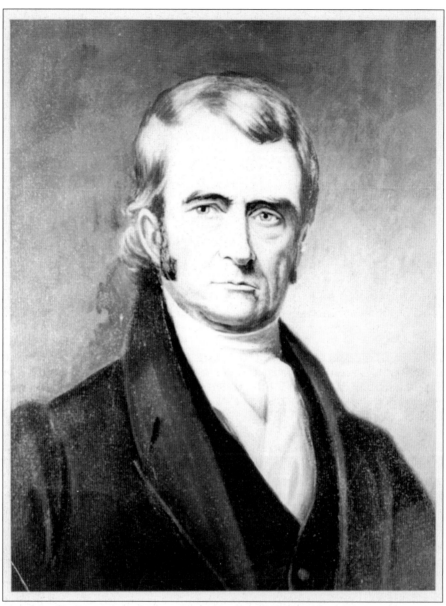

Like the school that carries his name, John Marshall was born in a log cabin on the Virginia frontier. He fought in the Revolutionary War, spending the frigid winter of 1777–1778 with George Washington and the American troops encamped at Valley Forge. After the war, he took up the law, served briefly in the House of Representatives, and was secretary of state under Pres. John Adams. In 1801, Adams appointed Marshall chief justice of the U.S. Supreme Court. He would occupy that post for 34 years, handing down a series of historic opinions that mark him as one of the great figures in American constitutional history. It was the Marshall court that established the principal of judicial review, holding that the high court had the power to declare invalid any act of Congress that was in conflict with the U.S. Constitution. Chief Justice Marshall died in 1835, two years before the founding of Marshall Academy; thus he never knew the school had been named for him.

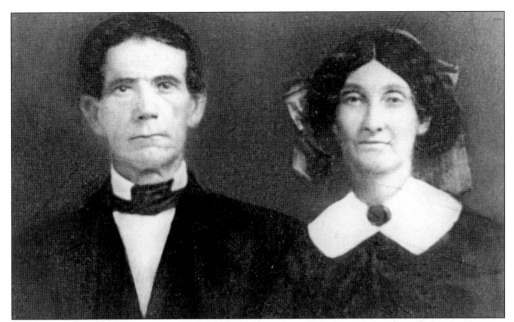

A number of Guyandotte area citizens played roles in the founding of Marshall Academy, chief among them attorney John Laidley, shown here with his wife, Mary Scales Hite. Laidley was a friend and admirer of Chief Justice Marshall, with whom he had served in the Virginia Constitutional Convention of 1829–1830, and it was at Laidley's behest that the new school was named for the famed jurist.

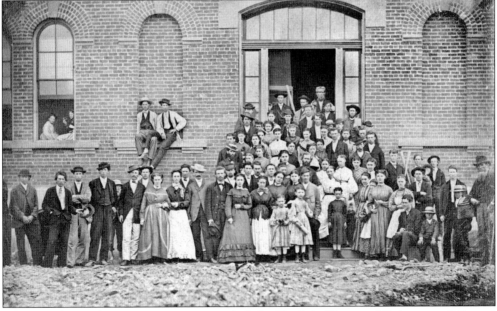

In 1858, the academy's trustees persuaded the Virginia House of Delegates to amend the school's charter and rename it Marshall College, although it remained a preparatory school, not a college as we know it. Closed during the Civil War, it reopened in 1867 as a state normal school chartered to train teachers. Most of the Marshall students gathered for this 1870 photograph soon would be in schoolrooms throughout the state.

It was under Lawrence J. Corbly that Marshall truly began to come into its own. Previously, the heads of the school had been called principals. Corbly, who served from 1896 to 1915, was the first to hold the title of president. He is shown here seated at the dining table with students in what is today the east end of Old Main.

Here is another photograph of President Corbly, this time pictured with a bevy of Marshall coeds. A scholar and world traveler, Corbly tightened academic standards at the school, requiring for the first time that all members of the faculty have at least baccalaureate degrees. During his tenure, Marshall's enrollment tripled, going from 222 students in 1896 to 670 in 1915.

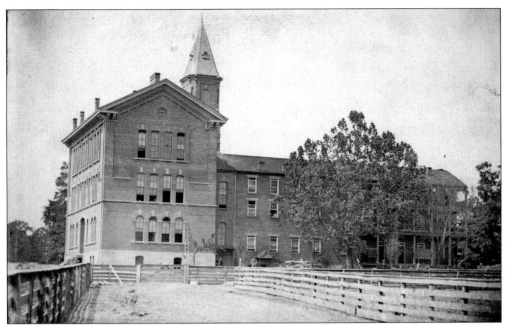

Marshall's Old Main, as it is known today, is actually a series of buildings constructed at various times over the years and eventually joined. This old photograph shows the south side of Marshall College State Normal School as it looked in 1885, certainly a far cry from the structure's future appearance.

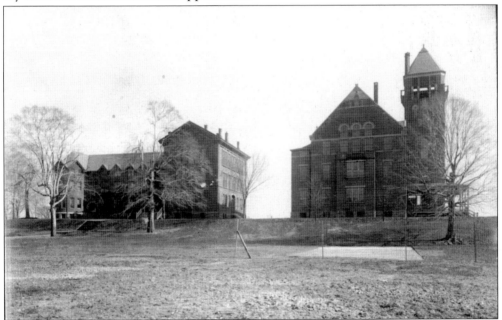

This view clearly shows the separate structures that eventually would be joined as Old Main. The peaked tower at right would later be demolished, and still later, the familiar castle-like towers would be added at the building's west side entrance, now generally considered its "front." The structure at left originally was called Ladies Hall and later College Hall.

In 1899, this doorway on the building's north side was the main entrance to Old Main, as proclaimed by the elaborate "Marshall College" carved beneath the arch. More than 100 years later, the doorway and stairs remain in daily use, prompting one to wonder how many thousands of students have made their way in and out of Old Main by this route.

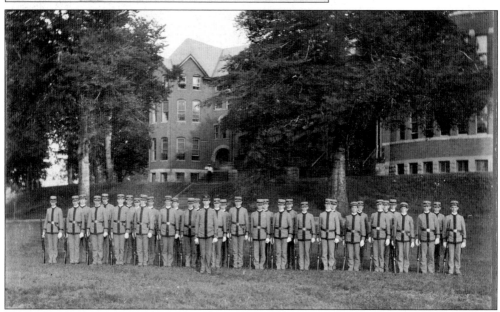

Today the Reserve Office Training Corps (ROTC) is a familiar part of campus life at Marshall, but the idea of military training for students is far from new. In 1902, Marshall had its own cadet corps, posing here in front of the north side of College Hall, now the rear section of Old Main.

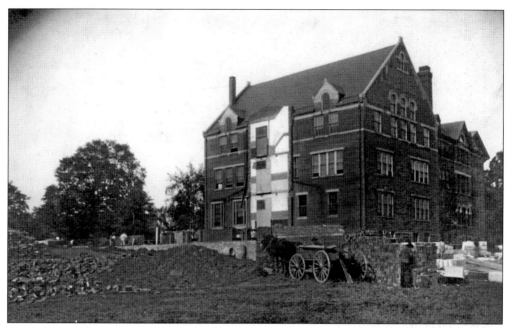

It is 1905, and construction is just starting on the last section of Old Main. The earlier tower has been torn down, and the foundation is going in for the new administration building. Note the mule and wagon, the standard means of hauling construction material before Henry Ford and his Model T came along.

This is the north side of College Hall, as seen from where Marshall's James E. Morrow Library now stands. Once College Hall and the administration building were joined, the combined structure would house classrooms, administrative offices, a library, a dining hall, an auditorium, a woman's dormitory, and even a basketball court in the basement.

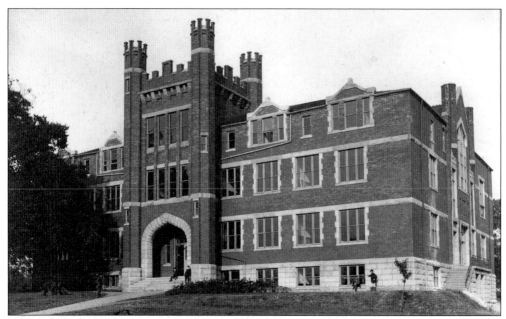

With the addition of its turreted towers, Old Main finally took on the appearance that has been familiar to generations of students. Over the years, the venerable red-brick building has suffered many complaints that it is obsolete and should be demolished. Instead, considerable effort—and money—has been expended to preserve the building for continued use.

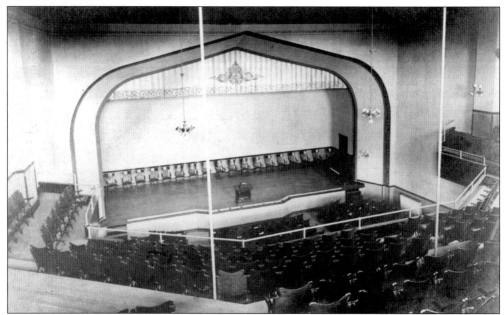

Here is the auditorium in Old Main in 1908, looking down from the balcony to the stage and first floor below. At that time, auditorium seats were individually assigned to students, with male students obliged to sit on one side of the aisle and female students on the other. The auditorium—with coed seating—remained in use until Marshall's new arts center opened in 1992.

16

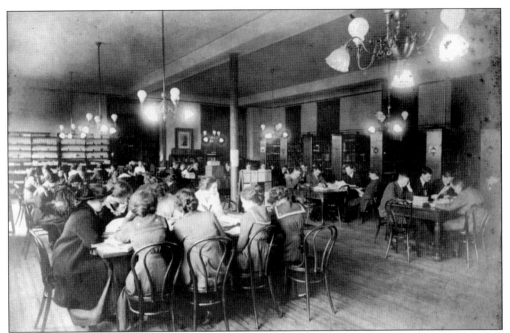

The school's library was located in Old Main in 1910. Another of President Corbly's achievements was to increase the library's collection from 1,200 volumes to 7,000. Again, as in the auditorium, the male students appear to be seated on one side of the room and the female students on the other.

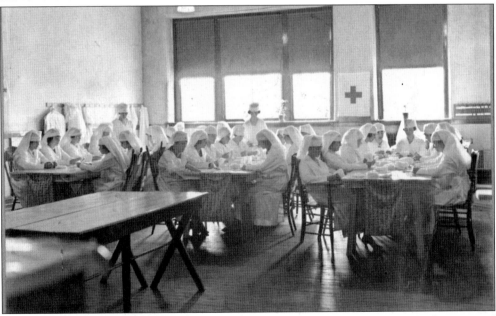

During World War I, Marshall coeds enrolled in the Red Cross Society, which prepared 20,000 surgical dressings and darned countless sweaters and socks that were sent to the American doughboys serving in France as well as to French and Belgian war refugees.Faculty and students raised $2,500, which they contributed to the Student War Friendship Fund.

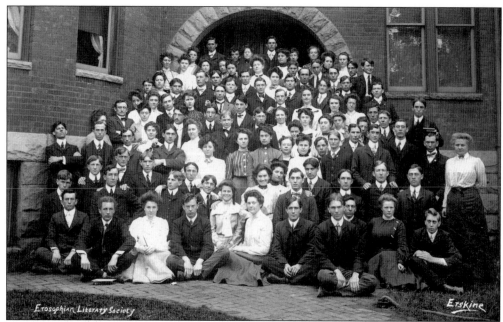

Campus life in the earliest years of the 20th century offered students a broad array of activities to choose from. The *Parthenon*, the student newspaper, made its first appearance in 1906, the first yearbook was published in 1909, and clubs welcomed members interested in particular subjects. Here, in a 1903 photo, are members of the Erosophian Literary Society.

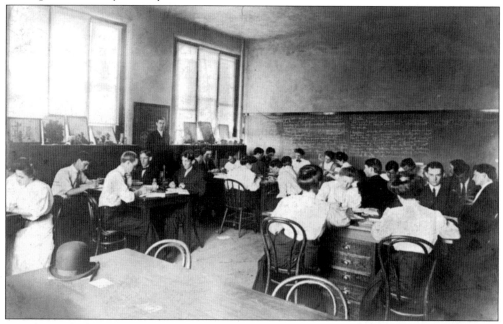

Members of a biology class meet in an Old Main classroom in 1908. Note the derby hat mysteriously perched on the otherwise empty table at lower left. Perhaps it belonged to the natty-looking professor or maybe to one of the male students, equally neat in their suit coats and neckties.

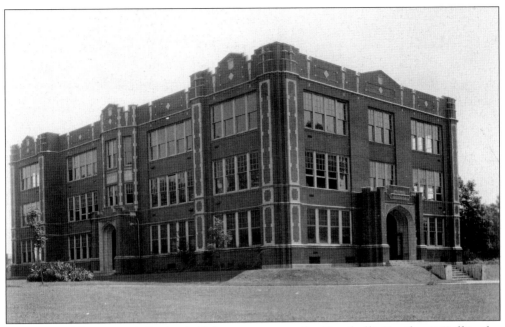

Members of the Masonic Lodge laid the cornerstone for Marshall's Northcott Hall in the fall of 1915, sealing in it a box containing various college memorabilia. The new building, occupied the following April, housed the various sciences as well as classrooms and a kitchen for the Department of Domestic Science. Northcott was demolished in 1995 to make way for the school's John Deaver Drinko Library.

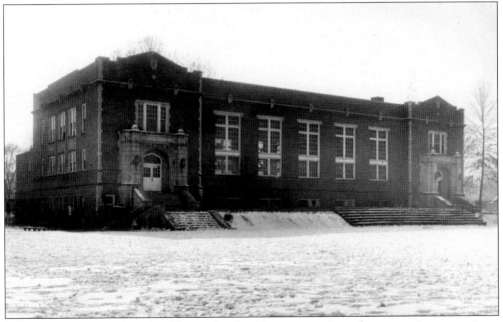

Marshall became a three-building school with construction of a women's gymnasium. The building was dedicated March 4, 1922, with a speech by Gov. Ephriam Morgan and a play, *The Gypsy Trail*, presented by the Dramatic Club under the direction of Vera Andrew. Badly dilapidated, the old gym was demolished in the 1980s.

This photograph and the one reproduced below offer an intriguing comparison. This undated early view shows the western entrance of the Marshall campus at Fourth Avenue and Sixteenth Street (later renamed Hal Greer Boulevard). A dapper-looking young man lounges against a wrought-iron fence. The sidewalk is brick. The street (not shown) would have been dirt. Only the busiest streets in downtown Huntington were paved at this point.

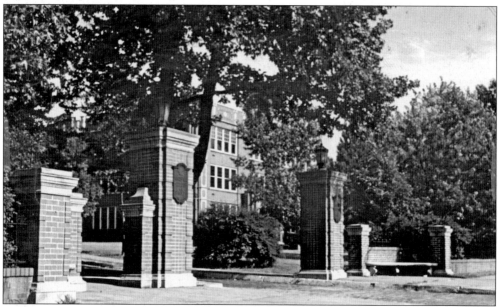

Flash forward a decade or two, and the wrought-iron fence shown above has gone, replaced by a handsome brick wall. A brick pillar stands on each side of the entrance. On each pillar is a bronze plaque, inscribed with "Marshall College," the school's official seal, and the date, "A.D. 1837." Beside each pillar is a stone bench, should one want to rest while waiting for a streetcar.

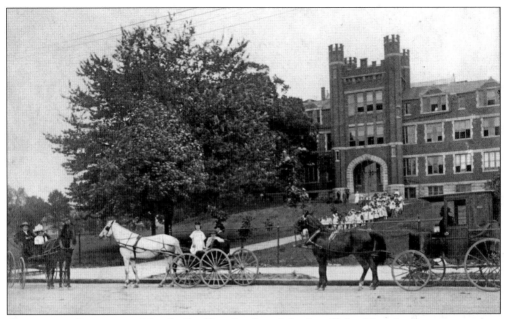

From its earliest years, Marshall offered a "model school" for Huntington youngsters, thus enabling future teachers to gain classroom experience. In this 1908 photograph, parents are waiting to pick up their children at the end of the school day. The horses and buggies lined up at the curb are a far cry from the SUVs that today's "soccer moms" drive to and from school.

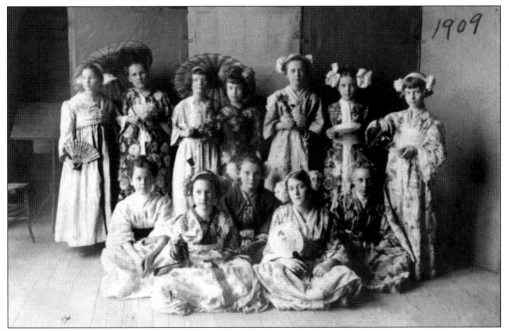

This 1909 photograph show a group of fourth-grade girls at Marshall's model school, taught by Harriet Lyons. The occasion for dressing up in kimonos was the conclusion of a project in which the girls studied Japan. The scene is a third-floor studio in Old Main, the usual domain of Emmett E. Myers, longtime chairman of Marshall's art department.

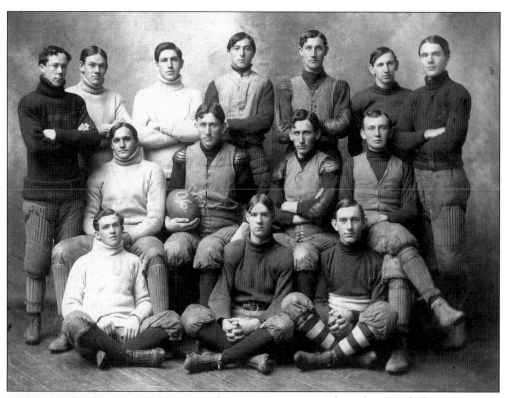

These brawny lads comprised the Marshall College football team of 1906, a time when Marshall mostly staged contests with squads from secondary schools. Even so, in 1905, a Marshall team under Coach Alfred McCray managed to defeat the Ohio University Bobcats. It would be 1911 before Marshall boasted a grid schedule that included only college-level schools.

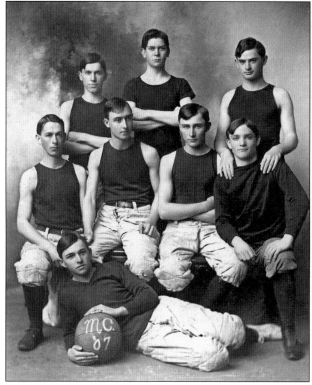

The inscribed basketball identifies these students as members of Marshall's 1907 team, but little more is known about them. Their outfits would seem to suggest they were ready for an afternoon of horseback riding rather than a session on the basketball court.

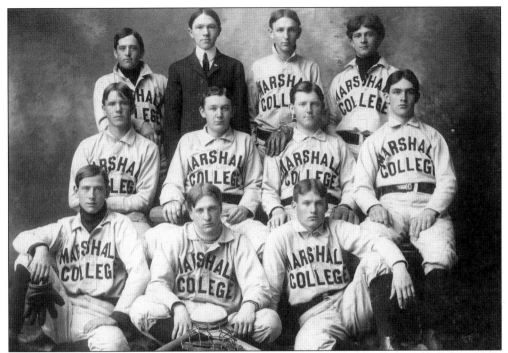

The date of this photograph of the Marshall College baseball team is unknown, but the players' hairstyles—many neatly parted in the middle—would suggest it was taken somewhere around 1900 or shortly thereafter. Note the old-fashioned baseball cap on the lap of the player in the middle of the front row.

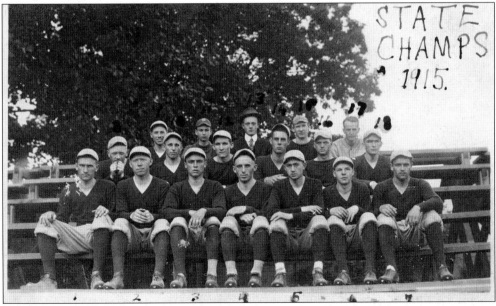

The hand lettering in the corner of this photograph, taken from an old postcard, identifies these serious-looking Marshall baseball players as the "State Champs" of 1915. Someone, presumably the same person, thoughtfully inked numbers beside each player so they could be identified, but unfortunately the accompanying list of names has not survived.

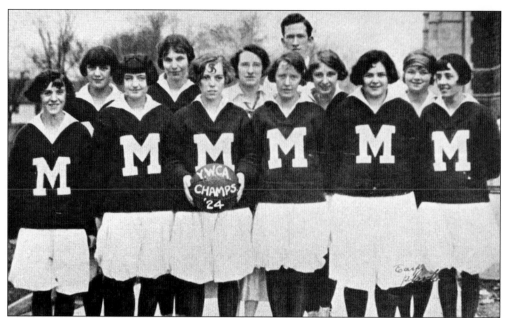

Prior to the 1920s, Marshall coeds, like their counterparts at other schools, engaged in athletic activities only to a limited extent. With their long hair and billowing skirts, they were hardly dressed for it. But with the advent of bobbed hair and short skirts, all that changed. In 1923, Marshall formed a women's basketball team, and the next year, as this photograph attests, the team took a YWCA championship.

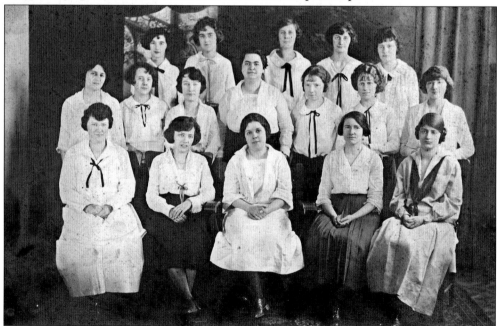

These were Marshall's home economics students in 1921–1922, a time when the school's future homemakers gained practical experience by catering meals for the Huntington Rotary Club and other organizations. Although the pairing now might seem strange, the domestic science department was housed with the other sciences in Northcott Hall.

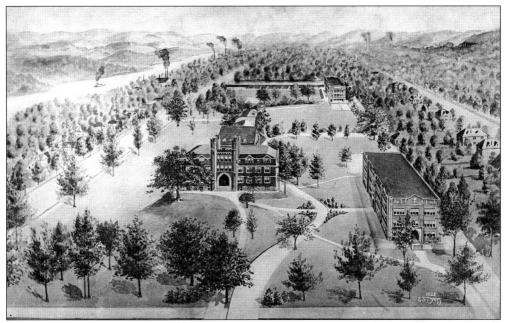

In 1923, art department chairman Emmett E. Myers sketched the three buildings that made up the Marshall campus. The view looks east from Sixteenth Street. At the center is Old Main, to the right is Northcott Hall, and at rear right is the women's gymnasium that was dedicated the year before.

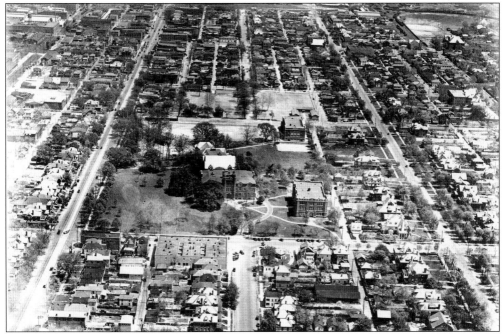

Here is the same view as shot from above by the Aero Service Corporation of Philadelphia in 1926. This aerial photograph gives a good look at not only the Marshall campus but also some of the houses and businesses that surrounded it. Many have since vanished, as the campus has dramatically expanded over the years.

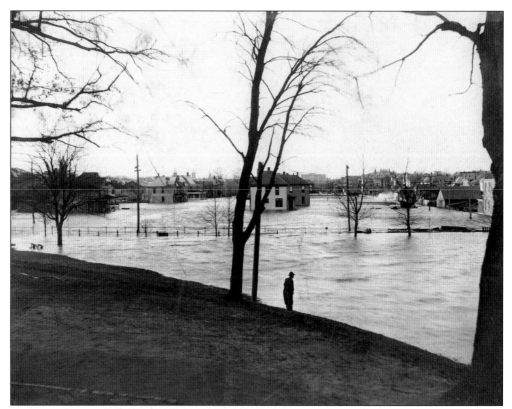

In 1913, the Ohio River flooded Huntington, driving an estimated 2,000 people from their homes. Old Main, perched on its hilltop site, was high and dry, but classes nonetheless were disrupted for some time. This view shows flooded houses as seen from Old Main. In future years, people would speak of 1913 as the "granddaddy" of all floods, but, unbeknownst to them, worse was ahead.

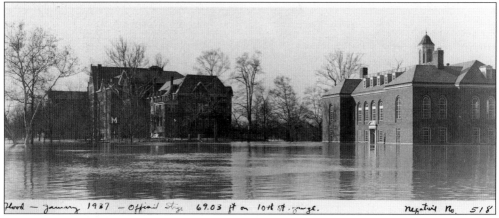

On January 27, 1937, the flooded Ohio River reached 69 feet—three feet higher than its 1913 crest. Virtually all of downtown Huntington was flooded, and much of the Marshall campus was turned into a lake. This view shows the rear of Old Main at left and the rear of the newly constructed James E. Morrow Library at right.

Two

ONE HUNDRED YEARS AND COUNTING

The 1930s proved to be a decade of growth for Marshall, with a number of new buildings added to the campus. With the nation in the grip of the Great Depression, Marshall's president was known to sometimes accept IOUs and even potatoes from students to cover their tuition. In 1937, the school celebrated its centennial with an impressive series of events and the issuing of this commemorative medal.

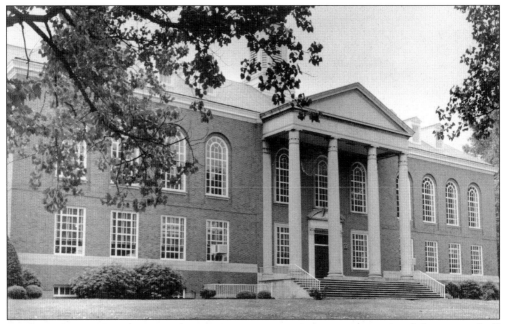

Dedicated January 30, 1931, the James E. Morrow Library was named for a Marshall principal (1872–1873), whose son, Dwight E. Morrow, was persuaded by Pres. Morris P. Shawkey to donate $25,000 to supplement the $200,000 the legislature had appropriated for its construction. The library was designed to house 130,000 books—quite an ambitious figure considering that Marshall's collection numbered only 25,000 books at the time.

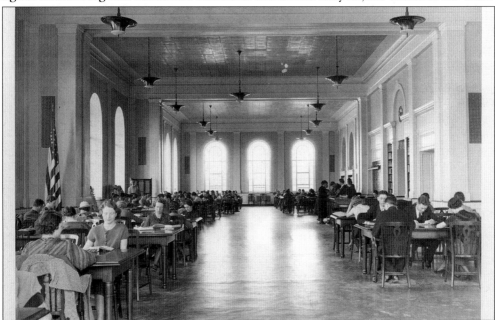

The Morrow Library's second-floor reading room was equally ambitious in its design, with space provided to accommodate 400 students. Here is a look at the spacious reading room as it appeared before a major wraparound addition was constructed at the library in the 1960s.

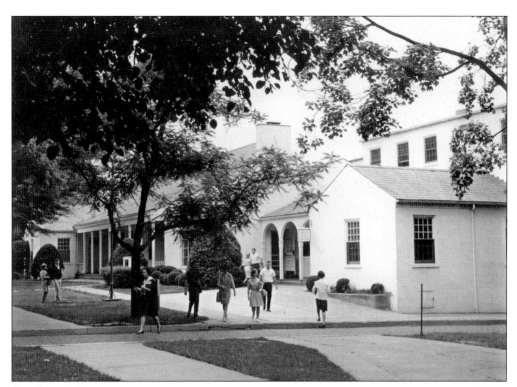

Another major campus addition during Morris Shawkey's term as president (1923–1935) was a student union building, described by Shawkey as a place "where students and faculty might meet on common ground." Dedicated in 1933, the building was built with a combination of student fees and public donations. Fittingly, it was named for Shawkey.

Morris Shawkey, who served as president at a critical time in Marshall's history, was largely responsible for winning accreditation for both the Teachers College and the College of Arts and Sciences. His resignation in 1935 was the result of a combination of factors, including his uncertain health and political pressure.

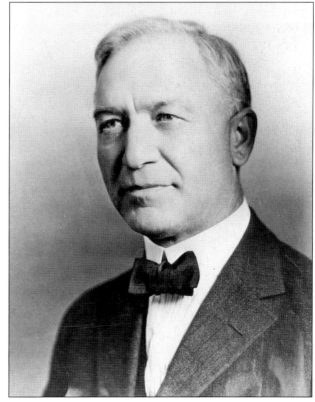

29

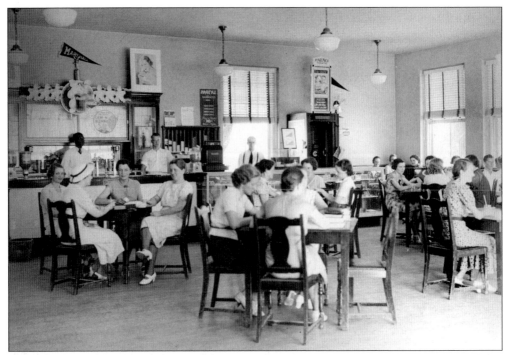

From the very first day it opened its doors, the soda fountain at the Shawkey Student Union was a popular gathering spot for students and many members of the faculty and staff. The old union building was demolished in the early 1970s, following construction of the new Memorial Student Center.

In addition to the always-crowded soda fountain, the Shawkey Student Union also had a comfortable lounge area. Marshall was one of the first schools of its size to construct a student union. In 1948, the National Association of Student Unions selected the Shawkey Union as a model for smaller colleges.

Arriving on the Marshall campus in 1935 as coach for both football and basketball, Cam Henderson would go on to become a Marshall legend. He certainly got things off to the right start when his undefeated 1937 football team won the Buckeye Athletic Conference championship and his 1938 basketball squad captured the conference title.

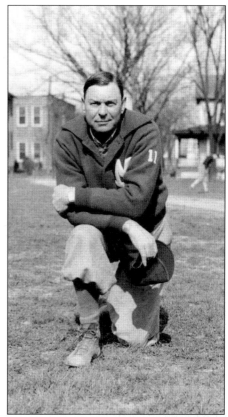

In the late 1930s, the federal Works Progress Administration (WPA), a New Deal program created to help put unemployed Americans back to work, built three new buildings on the Marshall campus: two dormitories and this, the Albert Gallatin Jenkins Teaching Training School. The $200,000 building was generally called simply the "Lab School."

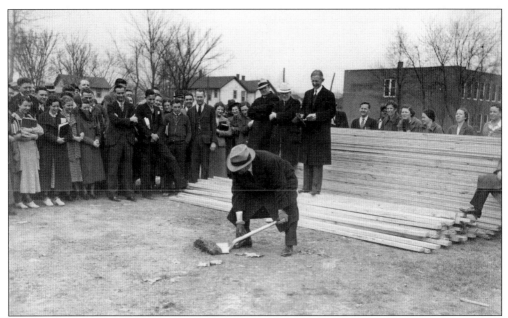

Ground is broken for the construction of Laidley Hall and Hodges Hall, built by the WPA at a total cost of $300,000. The great flood in January 1937 precluded occupancy of the new dormitories until the fall of the year. An adjacent cafeteria building was built in 1941.

This new dorm was named Laidley Hall in a long-overdue tribute to Marshall's chief founder. The second dorm was named Hodges Hall in honor of Thomas Hodges, who served as the school's principal for 10 years (1886–1896). Confederate general Albert Gallatin Jenkins was the namesake of the Training School, built by the WPA at the same time as the two dorms.

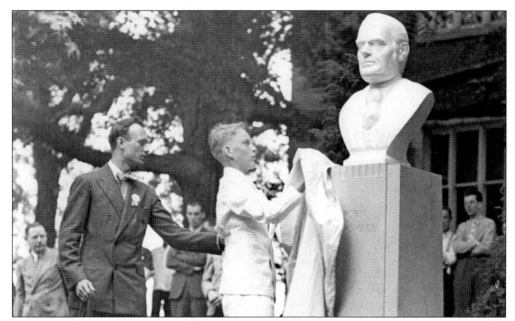

A highlight of the school's yearlong centennial observance in 1937 was the erection of the original bust of Chief Justice John Marshall in front of Old Main. Charles Marshall Scott, an 11-year-old great-great-grandson of the famed jurist, performed the dedicatory unveiling. Damaged by unidentified vandals, the original bust would be replaced by a second one in 1959.

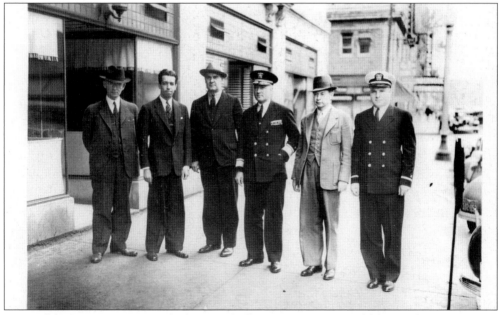

Created for 1937's centennial, the Marshall Artists Series would become a permanent tradition and over the years would bring hundreds of entertainers, authors, and public figures to the campus and community. The first to appear was famed polar explorer Adm. Richard E. Byrd, fourth from left. Prof. Curtis Baxter, who created the artists series and directed it for many years, is second from left.

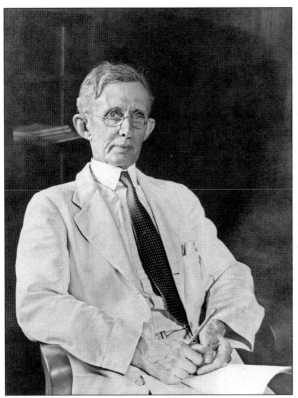

James E. Allen, a longtime president at Davis and Elkins College, became Marshall president in 1935 and served until 1942. His tenure was marked by both academic and athletic success but saw Marshall struggle with financial problems. On his retirement, Allen complained that he had been forced to administer a college with "a high school budget."

Marshall's centennial observance included the unveiling of colorful murals painted for the Morrow Library by Marion Vest Fors, a member of the art department. In this photo, Mrs. Fors is speaking with President Allen behind her. The murals were removed in the 1960s, when the building's ceiling was lowered. In 2005, efforts were initiated to refurbish and reinstall the murals.

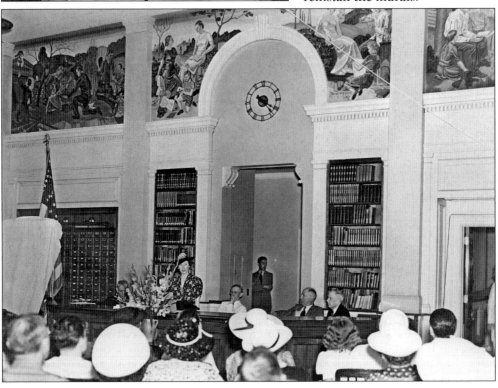

This photograph shows the scene on the stage at the Keith-Albee Theater for the Centennial Commencement of 1937. Speakers included Gov. Homer H. Holt and Dr. Douglas Southhall Freeman, the eminent biographer of Robert E. Lee and editor of the Richmond, Virginia, *News Leader*. President Allen is at the rostrum, with Holt (in light-colored trousers) and Freeman to his left.

Huntington's Col. Joseph Harvey Long, the dean of West Virginia newspapermen for more than half a century, was presented an honorary doctorate at Marshall's Centennial Commencement. Long stands at the center of this photo, with President Allen at left.

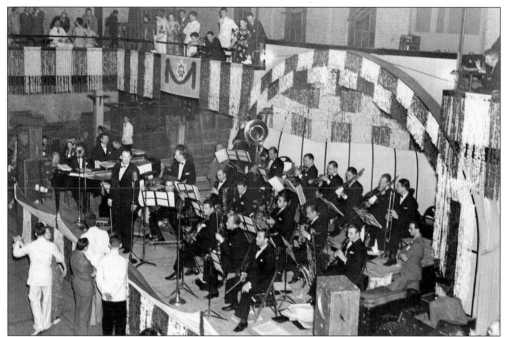

Paul Whiteman, billed at the time as the "King of Jazz," brought his talented big band to town for Marshall's Centennial Ball, conducted at Vanity Fair in downtown Huntington.

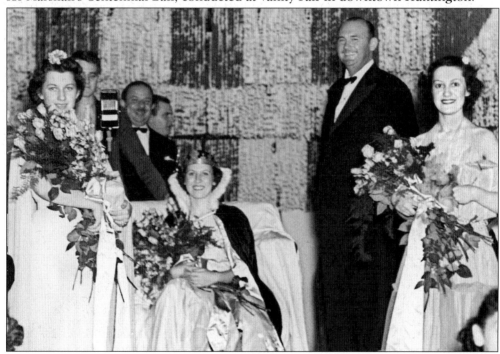

What is a fancy ball without a queen to preside over it? Here bandleader Whiteman, second from right, poses with Marshall's Centennial Queen, Jean Wilson, a sophomore from Pittsburgh. The queen's attendants were (at left) Maxine Davis, a senior from Glen Rogers, and (at right) Lonore Lamb, a Huntington junior.

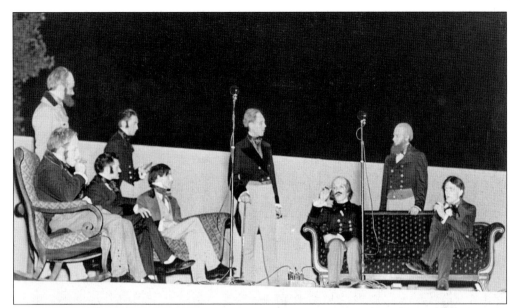

Approximately 5,000 people gathered in Huntington's Ritter Park amphitheater on two successive evenings in 1937 to witness a historical pageant celebrating Marshall's centennial. The scene shown here recreates a discussion at the Guyandotte home of John Laidley, where he shared with his friends his dream of establishing a new school.

The concluding scene of the centennial pageant was a torch ceremony, another example of how Marshall and other colleges of the day so frequently paid homage to what poet Edgar Allan Poe called "the glory that was Greece." Buell B. Whitehill and Otis Ranson of the speech department wrote the pageant, basing it in part on a history of Marshall written by jurist and local historian George S. Wallace.

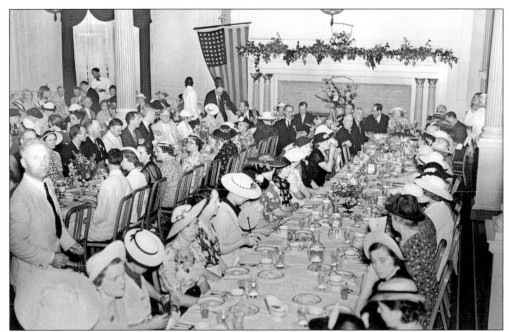

Huntington's Hotel Frederick was the scene of an elaborate centennial luncheon for alumni and other invited guests. In his landmark history *Marshall University: An Institution Comes of Age, 1837–1980*, Charles H. Moffat characterized 1937's ambitious program of centennial events as "a powerful spiritual and intellectual" tonic for the school.

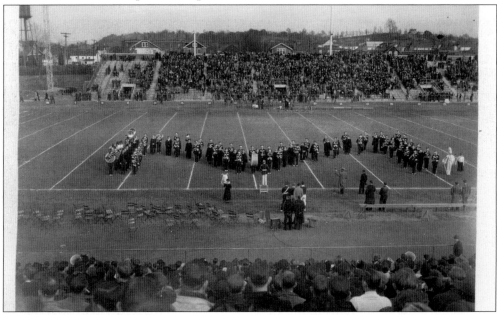

The Marshall marching band forms a giant letter *M* during football halftime ceremonies at Fairfield Stadium. The photograph is undated but appears to be from the late 1930s or perhaps 1940 or 1941. With the Japanese attack on Pearl Harbor on December 7, 1941, and America's entry into World War II, football Saturdays at Fairfield soon became a memory.

Three

IN WAR AND PEACE

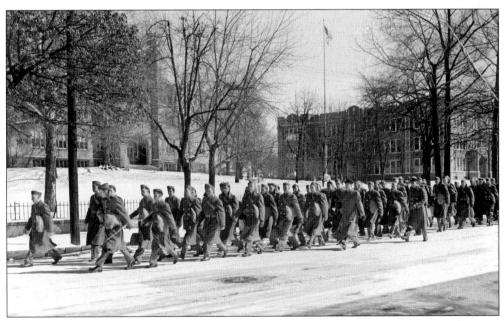

With the advent of World War II, Marshall College quickly shifted to a wartime footing. Enrollment declined drastically as young men entered the military. Khaki uniforms became a familiar sight as the Army Air Corps established a training center at Marshall. The Air Corps cadets are shown marching along snow-covered Sixteenth Street.

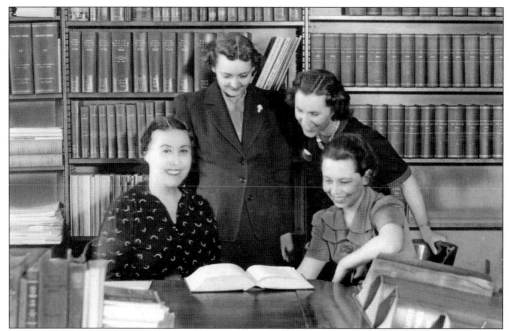

In the 1940s, students visiting the Morrow Library could look to these library staffers for help. From left to right are Rosa Oliver, Laura Miles, Margaret Bobbitt, and Bernice Dorsey. Rosa Oliver became Marshall's chief librarian in 1935 on the retirement of Louise Edmundson.

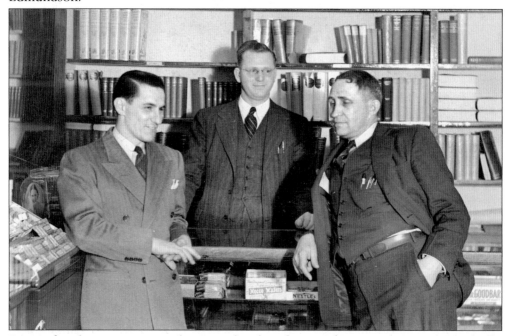

Posing for the camera in a photograph taken for a 1940s-era edition of Marshall's yearbook, *The Chief Justice*, are, from left to right, Cecil J Ferguson, manager of the Shawkey Student Union; Percy L. Galloway, bookstore manager; and James L. Mullen, superintendent of buildings and grounds.

This 1941 photograph shows the broad stairway leading up to the second-floor reading room of the Morrow Library, a popular meeting spot for students of that era. In his Marshall history, Charles Moffat chronicles that the state was so reluctant to appropriate money for Marshall's library in the 1930s and 1940s that many of its shelves sat empty. President Shawkey sought financial assistance from the Carnegie Foundation and additional help from the Morrow family but with no success. As a result, unused space in the library was converted into classrooms. Eventually, the twin pressures of a growing collection and a dramatically increased enrollment would not only fill that unused space but force construction of a major addition.

School spirits were high at Marshall in 1941, as represented here by a homecoming float shown circling the field at Fairfield Stadium, but the war soon put a damper on most college activities. Enrollment declined from 2,177 students in 1939 to a low of 720 students in 1944. Of that tiny enrollment, all but 60 were coeds.

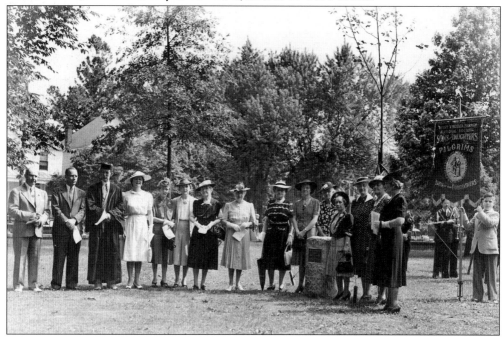

In 1941, the Sons and Daughters of Pilgrims conducted a campus ceremony, installed a stone marker, and planted a tree in honor of the nation's pilgrim settlers. The marker and tree still stand, located just west of the Morrow Library on Third Avenue.

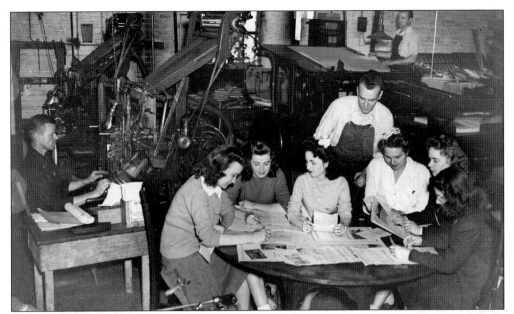

They called it the "Petticoat *Parthenon*" in the 1943–1944 school year, when women took over the reporting and editing of the campus newspaper. The editor was Betty Arrington Nichols, third from left, who went on to become a longtime journalism teacher at Huntington High School.

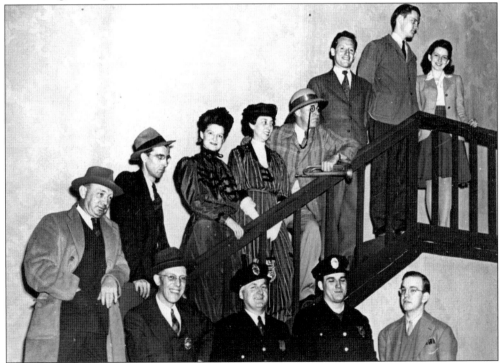

With male actors in short supply during the war years, Marshall College Theatre and the Huntington Community Players teamed up in 1943 to present a memorable production of *Arsenic and Old Lace*. Members of the cast gathered here for a publicity photo.

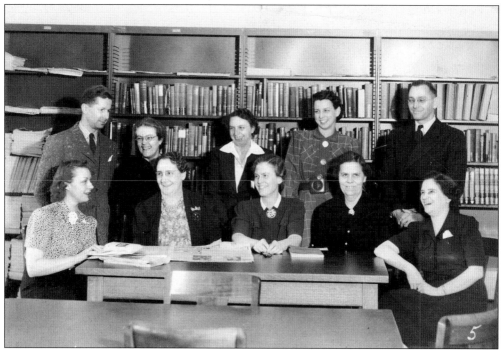

Members of the wartime faculty of the Jenkins Laboratory School gather for a portrait for use in *The Chief Justice*. The lab school was an integral part of Marshall's Teachers College until 1968, when it was closed in favor of assigning student teachers to local public schools.

The laboratory school quickly outgrew its quarters in the Jenkins building, forcing construction of this addition. Principals of the lab school over the years included Paul Musgrave, Lawrence Nuzum, Taylor Cremeans, and Rex Gray.

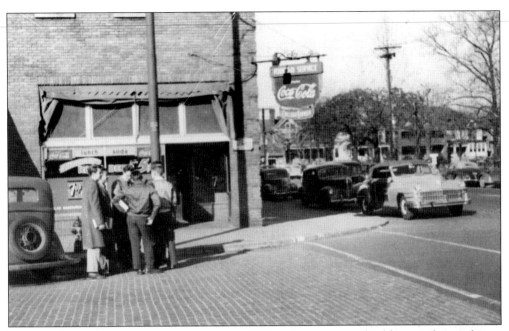

Under various ownerships and with differing names, the restaurant building on the northwest corner of Fourth Avenue and Sixteenth Street (later Hal Greer Boulevard) has been a popular hangout for students for decades. This snapshot dates from the late 1940s.

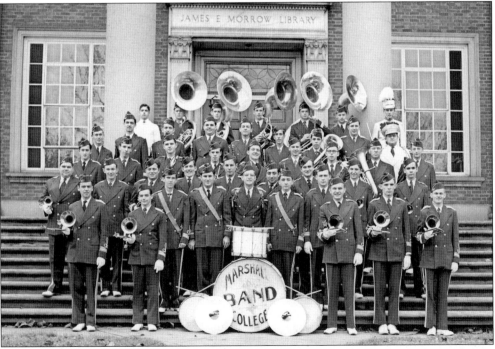

With the end of World War II, Marshall enrollment exploded as returning veterans decided to use their education benefits under the Montgomery G.I. Bill. That meant activities and organizations such as the band, shown here, could again become a big part of college life.

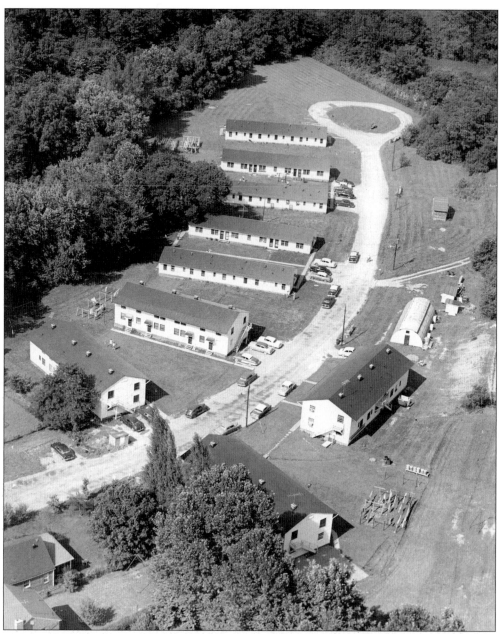

Uncle Sam, through the Federal Housing Administration, provided surplus pre-fabricated military housing for some of the hundreds of married veterans flocking to the campus after the war. Shown is an aerial view of the Donald Court housing complex erected on the southern outskirts of Huntington. Members of the Marshall faculty, like their counterparts on campuses elsewhere in the nation, quickly found the returning veterans to be far more mature and studious than prewar Marshall students. Little interested in the frills of campus life, they were intent on earning degrees as quickly as possible and getting on with their lives. Many graduated in three years, more than justifying the government's investment in their education.

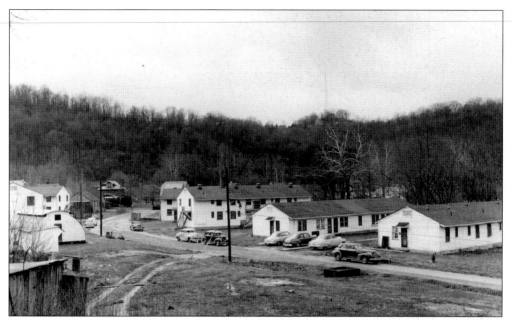

Here is another view of the Donald Court housing. The barracks-like appearance of the housing units shows their military origin. Still, with virtually no other housing available, vets and their families felt fortunate to set up housekeeping in them.

The postwar housing shortage was so acute that campus-area garages and other structures were converted into makeshift housing, and a complex of house trailers, called "Green Village," was installed on the east end of the campus. The name was a great deal prettier than the ugly-looking trailers themselves. Like the Donald Court units, the trailers were military surplus.

Not just housing but classrooms were needed for the tidal wave of returning vets who flooded the campus. Again the military provided the solution, when a former U.S. Navy barracks in Norfolk, Virginia, was dismantled and moved to the Marshall campus to provide urgently needed classroom space.

When it was erected in 1947, the former navy barracks known as Old Main Annex was described as a "temporary" structure. In fact, it would be used for the next 20 years, until the construction of Smith Hall.

Sadie Hawkins Day was the invention of Al Capp, creator of the "Li'l Abner" cartoon strip, set in the hillbilly community of Dogpatch. Capp conceived of a day when all the unmarried ladies of Dogpatch could pursue (literally) their men. If caught, the hapless bachelors soon found themselves trudging down the aisle. In the late 1940s and early 1950s, Marshall students celebrated the day in a big way.

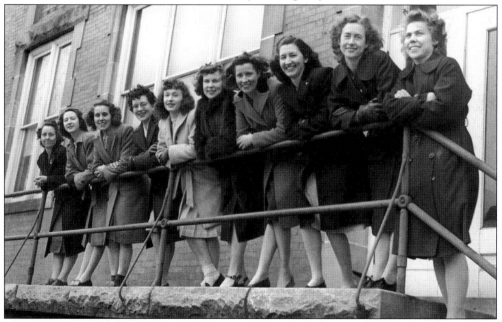

Not all the returning veterans who crowded the Marshall campus at the end of World War II were men. Lined up along a railing outside Old Main are, from left to right, Lavona Earl, Sally Anne Robinson, Clarice Fugate, Ruth Steel, Kay Hedrick, Margaret Carter, Minnie Mayes, Virginia Lucas, Costa Marshall, and Elisabeth Powers.

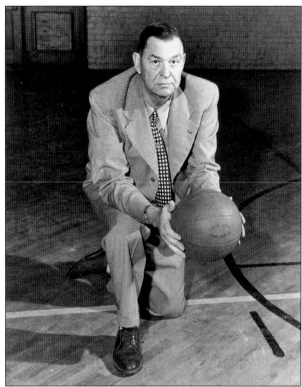

With no football team to coach during the war years, Cam Henderson busied himself giving swimming lessons to the Air Corps cadets on campus. With the war's end, Henderson resumed his coaching duties and added new laurels to his already illustrious career. He stepped down as football coach in 1950 and basketball coach in 1955.

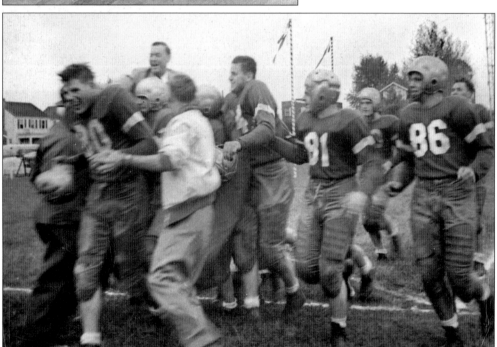

Celebrating Marshall football players carry Henderson, at left rear, off the field after a victory in the late 1940s. Henderson was, without a doubt, one of the finest two-sports coaches ever.

Four

THE FABULOUS FIFTIES

Marshall's journalism faculty in the 1950s consisted of, from left to right, Chairman W. Page Pitt, Chester Ball, and Virginia Lee. Today's W. Page Pitt School of Journalism and Mass Communications is named for the legendary journalism professor, who retired in 1967 after four decades of service to Marshall. All but blind, he refused to acknowledge that as a handicap.

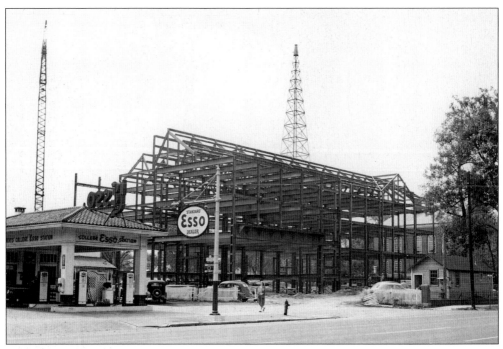

Prior to World War II, the state appropriated funds for construction of a new science building at Marshall to replace long-obsolete Northcott Hall. Military priorities precluded the building's construction for several years. Finally, work began in 1949 at a site on Third Avenue just east of Morrow Library.

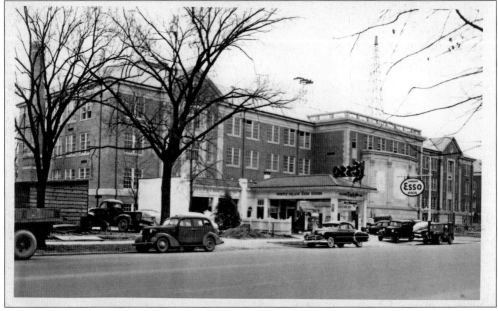

Here is the completed Science Hall shortly before it was dedicated in the fall of 1950—and also, it might be noted, before the neighboring Esso service station was demolished. John Dunning, dean of the College of Engineering at Columbia University, delivered the dedicatory address for the new $3-million building.

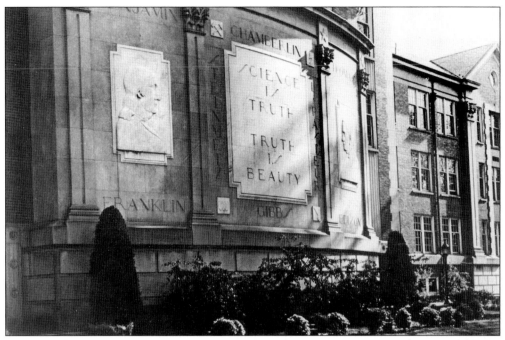

The handsome façade of the new Science Hall featured an impressive bas-relief sculpture, including giant-sized portraits of Benjamin Franklin and Thomas Edison and the names of other scientists and inventors.

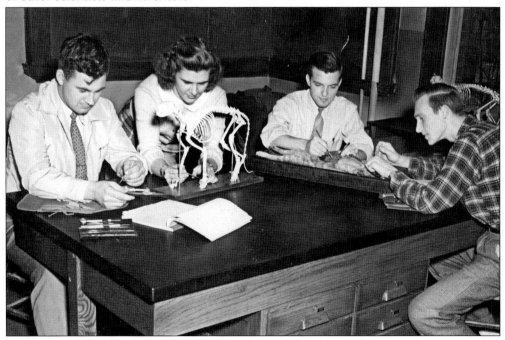

Comparative anatomy was the subject of this Marshall laboratory session, photographed in 1949. The date means the photograph would have been taken at Northcott shortly before all science classes and labs were moved to the new Science Hall. Opened in 1916, Northcott was home to all of Marshall's science departments for more than 30 years.

Botany students carefully sort specimens in a storage area at the new Science Hall shortly after it opened. Although considered spacious and modern at the time, the building quickly proved inadequate. In the 1980s, the long-delayed construction of a major addition did much to bring it up to date.

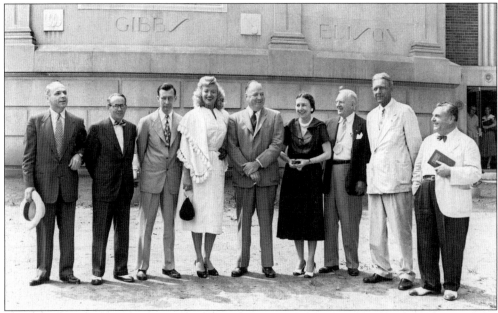

Yes, that is Huntington-born Dagmar, the blond bombshell of 1950s television, at the center of this photo. She was on campus in 1951 to present a $7,500 check for cancer research. From left to right are Pres. Stewart H. Smith, registrar Luther Bledsoe, Dr. Allen W. Scholl of the chemistry department, Dagmar, Alumni Association president Y. Jefferson Rife, college secretary Veta Lee Smith, director of evening programs Edward S. Macklin, Arts and Sciences dean J. Frank Bartlett, and Spanish professor Juan Fors.

At Marshall in the 1950s, homecoming was a huge event each year, with members of fraternities and sororities generally putting in all-nighters to complete work on elaborately decorated parade floats such as this one, shown with the 1951 homecoming queen and her court.

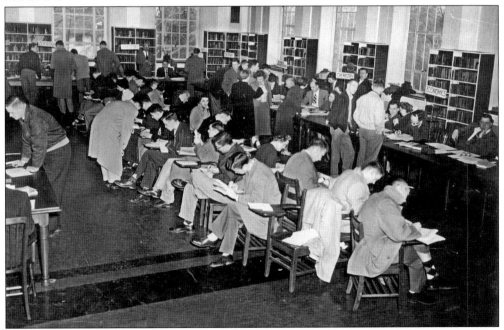

In the 1950s, the Morrow Library was pressed into service as a location for registration. In this 1953 photo, students are gathered in the library's second-floor reading room to fill out the reams of paperwork required—and often to plead for admission to a closed section of a needed course.

Lillian Buskirk was one of the best-known members of the Marshall administration for three decades. She became dean of women in 1941, at a time when strict rules for student conduct were in place, reflecting the standards of the day. By the time she retired in 1970, campuses had become increasingly less restrictive, with the Marshall campus reflecting that trend.

D. Banks Wilburn, a native of Shepherdstown in the state's eastern panhandle, was dean of Marshall's Teachers College for 17 years, from 1947 to 1964. Under his guidance, the Teachers College received national accolades and, at the close of his tenure, was one of the 10 largest teacher-training institutions in the nation. After leaving Marshall, Dean Wilburn became president of Glenville State College.

From the time he was named manager of Marshall's Shawkey Student Union in 1945, the always-affable Don Morris proved to be one of the best-liked individuals on campus. After presiding over the old union for 25 years, he hated to see it go but nonetheless eagerly played a major role in planning for the handsome new student center that replaced it.

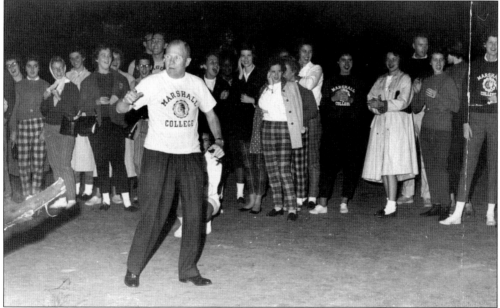

His given name was Otto Andrew Gullickson, but no one ever called him that. Physical education professor "Swede" Gullickson came to Marshall in 1930 and quickly created an intramural sports program that drew national recognition. He also carved out a role for himself as one of the Herd's most loyal—and most vocal—fans. Here he is seen whipping up the crowd at a 1959 pep rally.

Jules Rivlin made his mark as both a basketball player and coach at Marshall. A Pennsylvania native, he played three years for Cam Henderson, graduating in 1940 after accumulating a total of 1,189 points. In 1955, "Riv" returned to campus and took over for Henderson as basketball coach. He held the job until 1963. In his final game as coach, Marshall defeated St. Francis, giving Rivlin his 100th victory.

This building in the 600 block of Fourth Avenue was first the Vanity Fair auditorium, then later Radio Center, the home of radio station WCMI. Over the years, it was frequently the scene of Marshall dances and other events and, until Memorial Field House opened, was home court for Marshall basketball.

In a 1955 photo, an unidentified student studies in her room at Marshall's Freshman Dorm. As the enrollment grew, Marshall became increasingly short of dorm space. By the end of the 1950s, three coeds frequently were housed in two-person dorm rooms, and some male students were lodged downtown at the Hotel Prichard.

This *c.* 1955 photograph of the soda fountain at the old Shawkey Student Union must have been taken before the union opened in the morning or after it closed for the night. Nobody ever saw the busy fountain this deserted. When classes changed, thirsty students flocked in, with the resulting crowd at the counter often three or four deep.

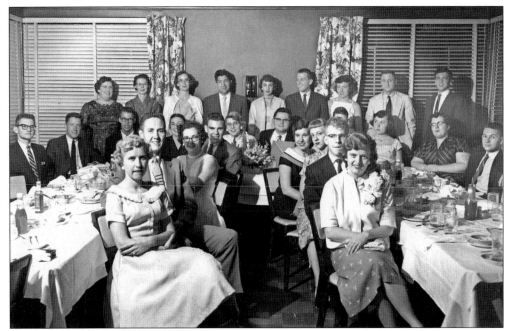

For many years, *The Chief Justice* was a valued annual record of school activities, and students eagerly vied for coveted positions on the yearbook staff. Here, the staff of the 1956 edition celebrates the completion of their work. In recent years, declining student interest and soaring costs have combined to make yearbooks a thing of the past on most campuses. The last edition of *The Chief Justice* was published in 1995.

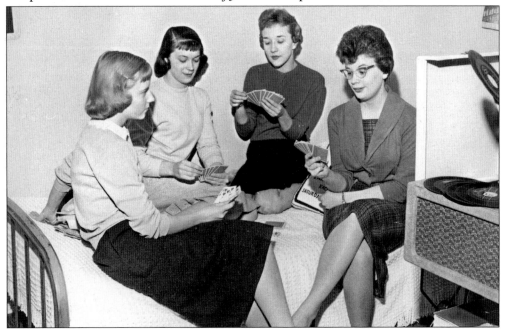

Marshall's dorm rooms of the 1950s were home to many a card game. The players in this one are identified as, from left to right, Carol Newman, Bonnie Semones, Dixie Ward, and Carolyn Ransbottom.

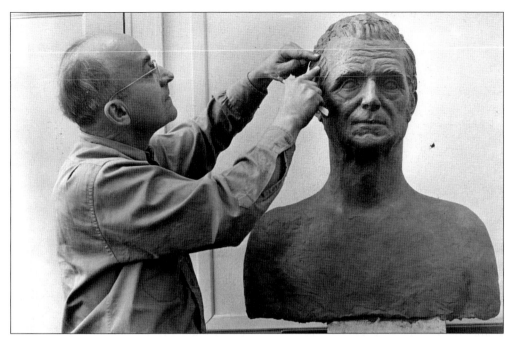

In 1957, an unknown vandal damaged the bust of John Marshall that had been erected in front of Old Main as part of Marshall's centennial celebration in 1937. Marshall art professor Joseph Jablonski was commissioned to create a new bust to replace the damaged one.

With Jablonski carefully supervising, workers place the pedestal for the new bust. Funding for the replacement bust came from A. R. "Snooks" Winters (class of 1919), with Harry McColm Jr., president of a local monument company, donating the new granite pedestal. The new bust was dedicated in ceremonies on May 9, 1959.

The historic old beech tree that stood in front of Old Main is said to have been growing there when Marshall was founded in 1837. Seventy feet high and measuring 11 feet in circumference, the old tree carried hundreds of initials carved into it over the decades. In 1987, most of the tree fell crashing to the ground, and the shattered stump had to be removed. A portion of the wood from the tree was carefully saved and fashioned into an official mace, which is now carried in the faculty procession at commencement and other official university functions.

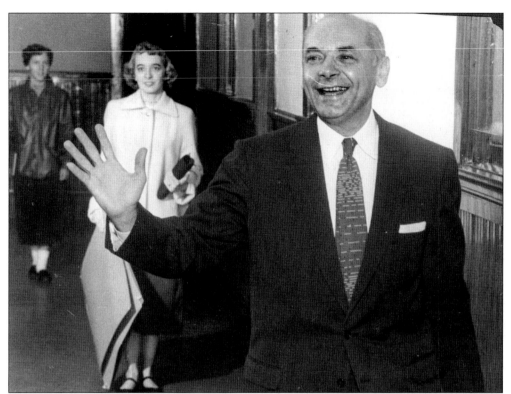

Popular with students, faculty, and the community, Stewart H. Smith served as Marshall president for more than two decades, longer than any of his predecessors. He was dean of the Teachers College in 1946, when the West Virginia Board of Education appointed him to succeed Pres. John D. Williams.

In his history of Marshall, Charles H. Moffat describes Evelyn Hollberg Smith as "a lady of exceptional grace" and recalls she was "extremely popular with the faculty wives." In 1967, she was named West Virginia Mother of the Year.

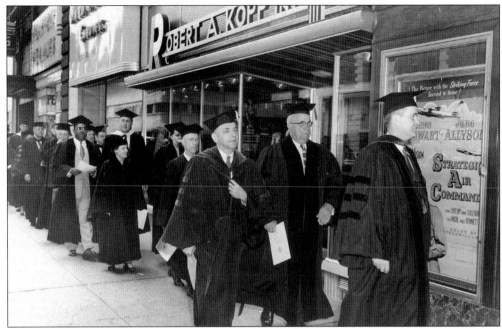

Clad in traditional academic regalia, President Smith and other members of the faculty and administration march to the Keith-Albee Theatre for commencement ceremonies in 1955. Longtime Huntington residents will recognize two vanished Fourth Avenue stores in the background: Robert A. Kopp, which sold men's clothing, and Maud Muller Candies.

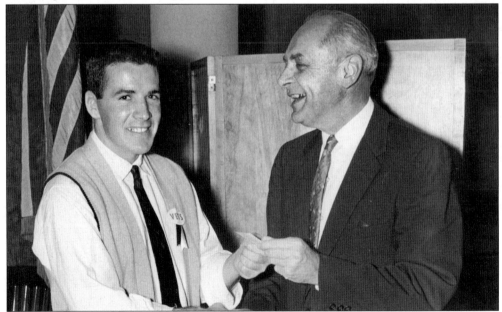

Here are President Smith and a future mayor of Huntington during Bob Nelson's days as a student and, as the badge on his chest indicates, a member of Marshall's Veterans Club. In this undated photo, the future politico appears to have succeeded in selling Smith a ticket for something. Nelson later served in the West Virginia Legislature and was Huntington mayor from 1986 to 1993.

Five

"WE ARE NOW . . . MARSHALL U"

Gov. W. W. Barron came to the campus on March 2, 1961, and, in ceremonies at Gullickson Hall, officially signed legislation designating Marshall as a university. An audience of 3,000 students, faculty, and townspeople crowded into the gym to hear Barron say it was his "privilege and pleasure" to sign the legislation. "It is my sincere wish," the governor said, "that Marshall's future will be resplendent with new pride and progress."

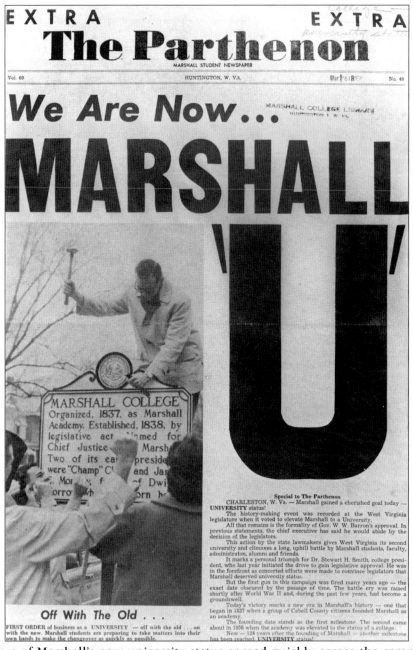

The Parthenon

MARSHALL STUDENT NEWSPAPER

Vol. 60 HUNTINGTON, W. VA. Mar. '61 REP No. 40

We Are Now...

MARSHALL COLLEGE LIBRARY
HUNTINGTON, W. VA.

MARSHALL 'U'

MARSHALL COLLEGE
Organized, 1837, as Marshall
Academy. Established, 1838, by
legislative act ... named for
Chief Justice ... Marsh ...
Two of its ea ... preside ...
were "Champ" C ... and Ja ...
... Mor ... f ... f Dwi ...
orro ... wh ... rn h ...

Special to The Parthenon

CHARLESTON, W. Va. — Marshall gained a cherished goal today —
UNIVERSITY status!

The history-making event was recorded at the West Virginia
legislature when it voted to elevate Marshall to a University.

All that remains is the formality of Gov. W. W. Barron's approval. In
previous statements, the chief executive has said he would abide by the
decision of the legislators.

This action by the state lawmakers gives West Virginia its second
university and climaxes a long, uphill battle by Marshall students, faculty,
administraton, alumni and friends.

It marks a personal triumph for Dr. Stewart H. Smith, college presi-
dent, who last year initiated the drive to gain legislative approval. He was
in the forefront as concerted efforts were made to convince legislators that
Marshall deserved university status.

But the first gun in this campaign was fired many years ago — the
exact date obscured by the passage of time. The battle cry was raised
shortly after World War II and, during the past few years, had become a
groundswell.

Today's victory marks a new era in Marshall's history — one that
began in 1837 when a group of Cabell County citizens founded Marshall as
an academy.

The founding date stands as the first milestone. The second came
about in 1858 when the academy was elevated to the status of a college.

Now — 124 years after the founding of Marshall — another milestone
has been reached. UNIVERSITY status!

Off With The Old . . .

FIRST ORDER of business as a UNIVERSITY — off with the old . . . on
with the new. Marshall students are preparing to take matters into their
own hands to make the changeover as quickly as possible.

The news of Marshall's new university status spread quickly across the campus and
community. Helping spread the word was this special issue of the school's newspaper,
The Parthenon. The undated edition of the newspaper was prepared in advance and
held until state lawmakers voted their approval of the big change. President Smith
and Marshall supporters won the long-sought goal of university status only after an
unprecedented lobbying effort. University status was essential, Smith argued, if Marshall
was to "occupy its vital role in the future of higher education in our state." Supporters
of West Virginia University argued that the state could not afford two universities, but
Smith and Marshall's friends in the legislature and elsewhere prevailed.

In a photograph taken in the early 1960s, President Smith and A. E. McCaskey, then dean of the College of Applied Arts, are shown visiting Fort Knox, Kentucky. There they inspected Marshall's ROTC cadets doing their summer training. McCaskey, visible here just behind Smith, was a Marshall professor and administrator from 1936 to 1971.

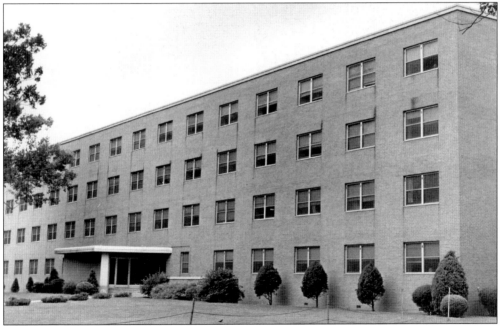

Originally constructed in 1955, the women's dormitory long known simply as the Freshman Women's Dormitory finally got a name in the 1960s when it was christened Prichard Hall in honor of Lucy Prichard, who taught Latin and classical studies at Marshall from 1914 to 1941.

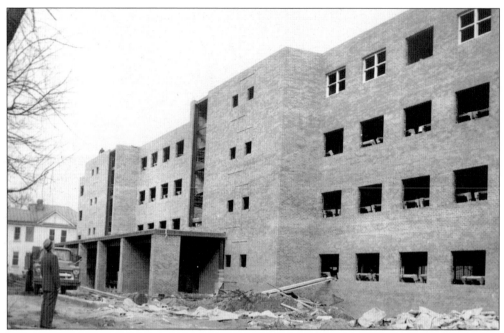

The men's dormitory first known as South Hall, shown here in a 1963 construction photograph, later gained more floors and a new name when it was named Holderby Hall in honor of James Holderby (1782–1855), one of the early Cabell County residents who joined with John Laidley in establishing Marshall.

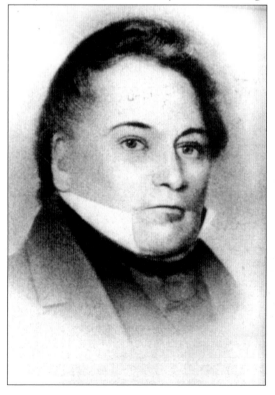

James Holderby and his brothers, William H. and Robert, owned much of the land that today comprises Huntington. He served as sheriff and as a member of the county court but is best remembered for the river wharf that carried the family name, Holderby's Landing. Located at the foot of what is now Hal Greer Boulevard, the landing was a busy place when the Ohio River was the county's primary artery of commerce.

A former Kroger supermarket, this structure—located where the Twin Towers dorms now stand—was used for Marshall's engineering program in the 1960s and early 1970s. In a decision that remains controversial, the board of regents eliminated engineering at Marshall in 1971, arguing that engineering classes at West Virginia University and the West Virginia Institute of Technology were more than adequate for the state's needs.

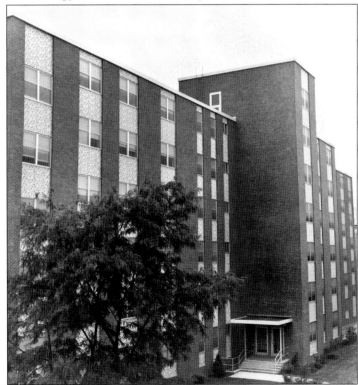

First known as West Hall when it was built in 1963, this women's dorm was later named Buskirk Hall in honor of Lillian Holmes Buskirk, Marshall's longtime dean of women.

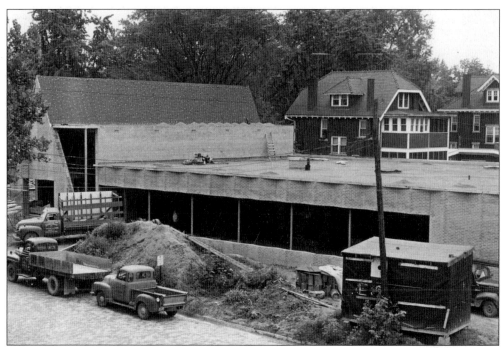

Shown in a 1960 construction photograph, Marshall's Campus Christian Center, located just south of the old women's gym, was built entirely by private contributions from churches and individuals of many faiths.

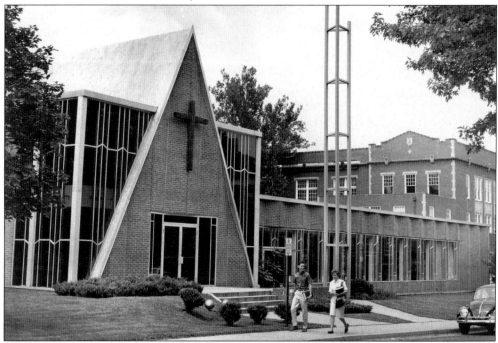

Completed and opened in 1961, the Campus Christian Center contains a chapel, fellowship hall, lounges, conference rooms, and offices. It serves not only as a house of worship but is frequently used for weddings, receptions, and other events.

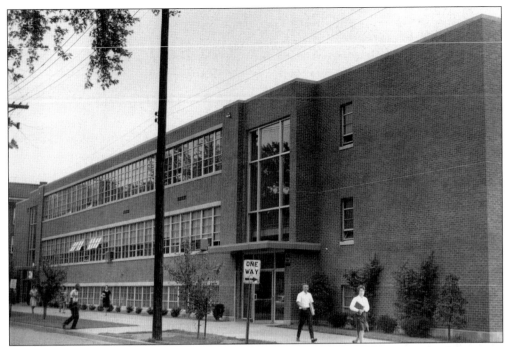

Built at a cost of $2 million, Marshall's new men's physical education building was dedicated in ceremonies conducted March 3, 1961. In 1964, the building was named Gullickson Hall in honor of Otto "Swede" Gullickson.

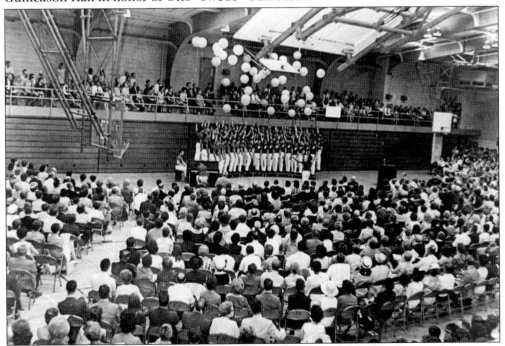

A highly popular event at Marshall during the 1960s was the annual Mother's Day Sing, a choral competition between fraternities, sororities, and other groups. Gullickson Hall was the setting for this edition of the competition.

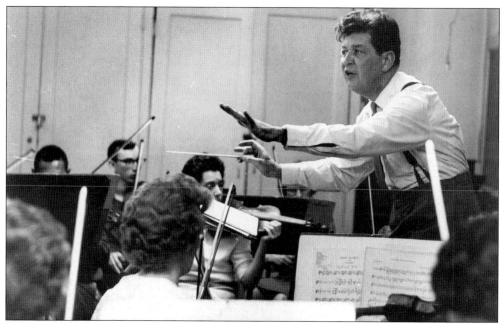

Prof. Alfred P. Lanegger rehearses the Marshall University Community Symphony Orchestra for a 1964 concert. A member of the Marshall faculty from 1947 to 1976, Lanegger directed the community symphony's free concerts for several years, drawing on the talents of Marshall students and other musicians living in the area.

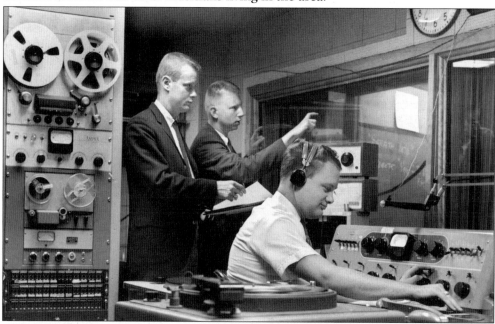

In a photograph dating from the early 1960s, program director Adrian Gobell, a senior from Fairlawn, New Jersey, standing at center, cues announcers in the studio of Marshall radio station WMUL. Assisting Gobell are Huntington juniors Charles Evans (left) and, seated, Dan Stahler. WMUL took the air in November 1961 as West Virginia's first educational radio station.

To relieve overcrowded conditions in Old Main, Marshall's music department was moved to this former brick store building in 1926. The building quickly proved inadequate but nonetheless would remain the department's home for more than 40 years, until it was moved to the new Smith Music Hall in 1967.

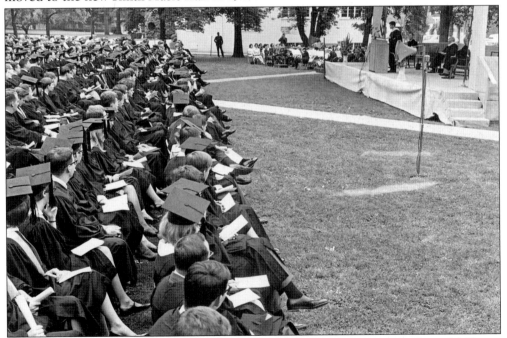

Over the years, Marshall has conducted commencement exercises in a number of different locations, both inside and outdoors. This view from the mid-1960s shows an outdoor ceremony conducted on the campus lawn between Old Main and Northcott Hall.

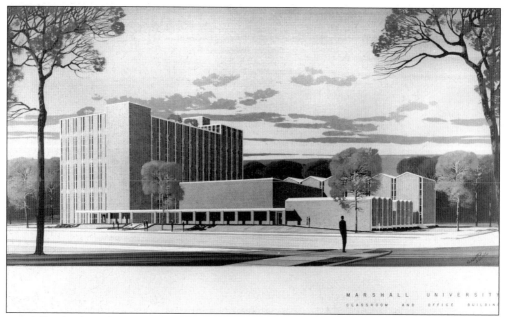

In 1963, the West Virginia Legislature approved a $7-million bond issue for campus construction (to be repaid through student fees), and Marshall resolved to use a major share of that money to construct a new classroom building at the corner of Sixteenth Street and Third Avenue. The building is shown here in an architect's sketch.

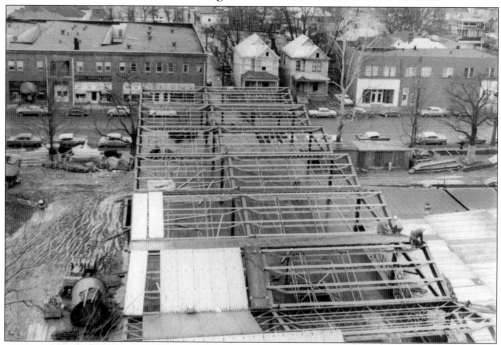

An annex at the eastern end of the new classroom complex was designated the Communications Building, while another at the western end finally provided adequate quarters for the university's music department. This view, which faces west, shows steelwork going up for the music annex.

To the surprise of President and Mrs. Smith, dedication ceremonies in December 1967 included an announcement that the new classroom building was to be named Stewart H. Smith Hall and the music annex would be christened the Evelyn Hollberg Smith Music Hall.

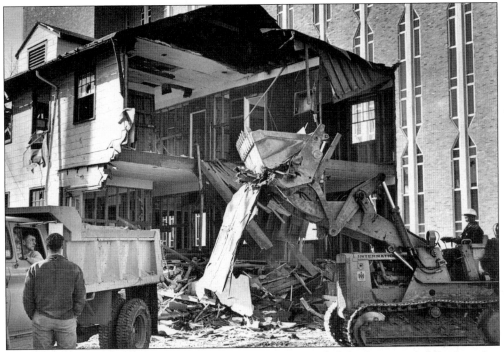

With the completion of Smith Hall, Marshall no longer needed the "temporary" Engineering Building that had housed classes for 20 years. A bulldozer made short work of demolishing the old frame structure.

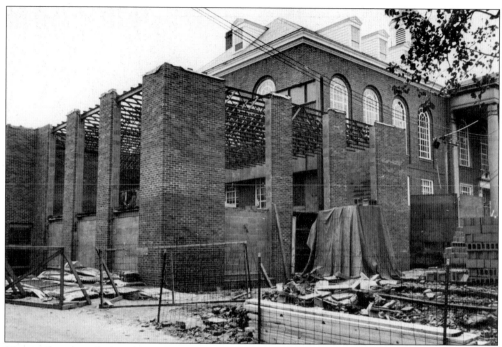

The 1960s saw federal funds used for a major renovation and modernization of the James E. Morrow Library, including construction of two wraparound annexes adjoining the original structure.

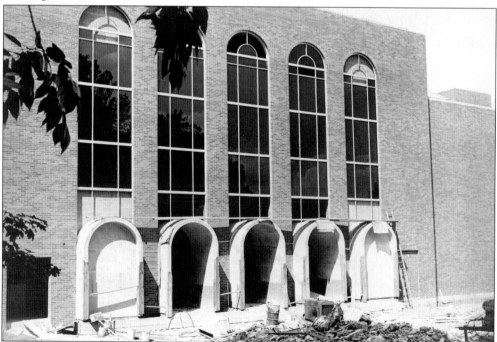

The Morrow Library's renovation included a new entrance on the campus side of the building, shown here during construction. When completed, the new entrance opened on to an inviting plaza.

An unidentified cheerleader decided to try her hand at impersonating Marco, the university's buffalo mascot, in this scene at a 1960s football game at old Fairfield Stadium.

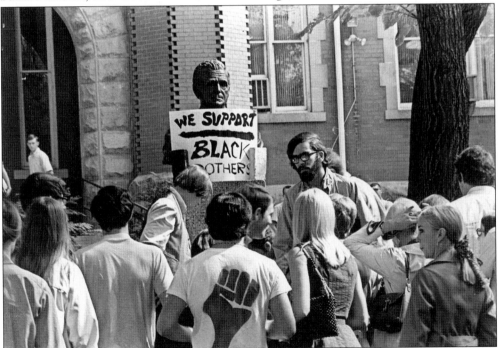

The 1960s were a period of unrest and protest on campuses across the nation, and Marshall was no exception. Here, in an undated photograph, protesting students rally in front of Old Main and press the bust of John Marshall into service as a handy place to post a sign.

In 1968, Roland H. Nelson Jr. was appointed Marshall's president, succeeding the retiring Stewart Smith. Nelson's tenure at Marshall was marked by student unrest, athletic scandal, and strained relations with the newly created state board of regents. After 22 months in the post, he resigned.

Ask Marshall students from the 1960s to talk about what they recall from their campus days and many surely will cite "standing in line." Registration each semester meant lining up to get a schedule of courses, to pay tuition and fees, and then, of course, to purchase textbooks. Here a long line snakes its slow way into the registrar's office in Old Main.

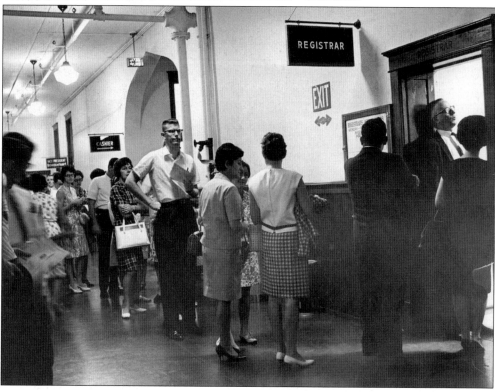

The late 1960s and early 1970s saw Marshall's basketball program regain much of its former luster, first with Ellis Johnson as coach, then under Carl Tacy. One of the standout players from the era was Russell Lee (1969–1972), who turned in a career scoring average of 23.9 points per game and was selected an All-American in 1972.

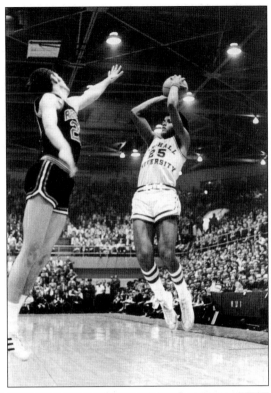

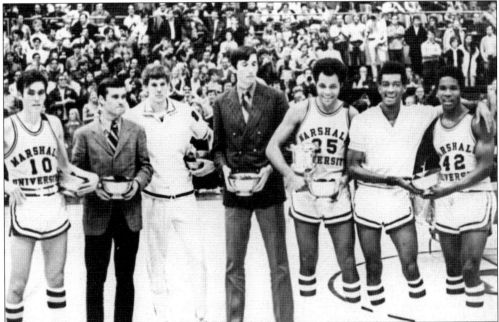

Mike D'Antoni, at far left in this Marshall Memorial Invitational Tournament trophy presentation, played from 1970 to 1973 and earned a single-season record for assists with 241 in the 1971–1972 season. He would go on to a legendary career in professional basketball, as both a player and coach in the NBA, the ABA, and the Italian League.

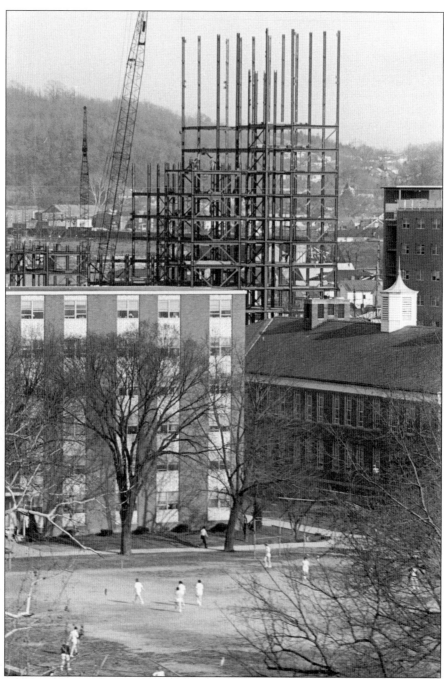

The steelwork for one of Marshall's Twin Tower dormitories goes up in this construction photograph. The two buildings, completed in 1969, are exact duplicates of each other. Capable of housing 500 students each, the two towers stand 15 stories high and, when completed, significantly altered the Huntington skyline. To further ease the housing shortage on campus, facilities for married students, located on University Heights, were also occupied in 1969. Three buildings offered a total of 42 apartments, all completely furnished and air-conditioned.

Six

TRAGEDY AND REBIRTH

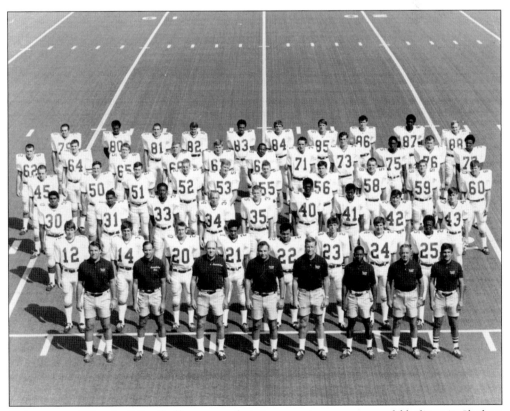

If the story of Marshall football were made into a movie, no one would believe it. Shaken by the worst tragedy in U.S. sports history, the school's football game did not just survive, it thrived into one where "We play for championships!" became not a boast but the plain unvarnished truth. Here the members of the 1970 Marshall football team proudly pose for a pre-season photograph unaware of the disaster that loomed just a few weeks ahead.

THE HERALD-ADVERTISER

Final

HUNTINGTON, WEST VIRGINIA, SUNDAY MORNING, NOVEMBER 15, 1970 ★★★ 76 Pages—8 Sections—25 Cents

Marshall Team, Coaches, Fans Die In Plane Crash

75 Believed Aboard Plane; Airline Silent

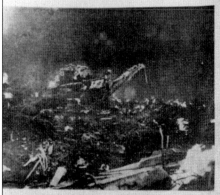

...aming Debris All That Remains ...

r. Moore Declares At Scene:

'Tragedy Of Highest Degree'

List Of Players Believed Aboard

Coaches

GOV. ARCH A. MOORE AT SCENE

...Of Chartered Airliner

25 Fans, Officials On List

Inside

Additional photographs, stories, reports. Pages 13, 32 and 33.

On November 14, 1970, a chartered jetliner crashed at Huntington's Tri-State Airport, killing all 75 people aboard: 37 members of the Marshall football team, 5 coaches and athletic officials, the aircraft's crew, and a number of the community's leading citizens, who had traveled with the team to a game in Greenville, North Carolina. Sunday morning's issue of *The Herald-Advertiser* reported the sad news of the Saturday night crash.

Officials examine the wreckage of the crashed aircraft that carried the Marshall football team and others to their deaths. Marshall and the community were plunged into mourning by the crash and would be a long time recovering. Even today, the emotional wounds from the tragedy remain. Some scars never heal.

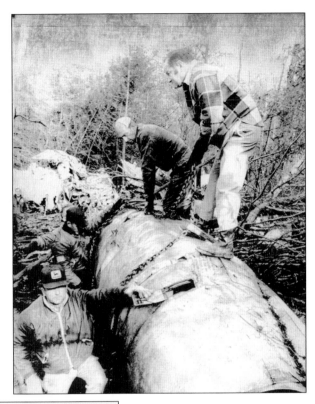

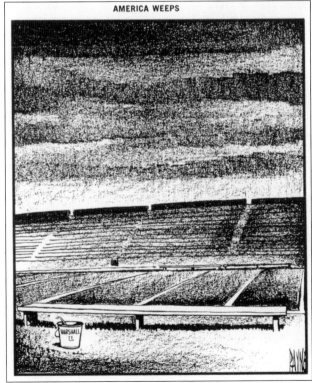

AMERICA WEEPS

MARSHALL U.

The Marshall crash was headline news across the country and around the world and sparked innumerable tributes and expressions of sympathy. "America Weeps" was the caption for this editorial cartoon that was published in the Charlotte, North Carolina, *Observer*.

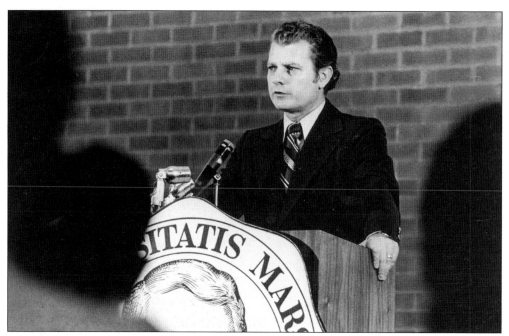

John Barker, then associate director of the Southern Association of Colleges and Secondary Schools, was named Marshall president in 1971. He is shown here delivering his State of the University address on August 27, 1972, in which he voiced "increasing optimism about the possibility of a medical school at Marshall."

Marshall managed to patch together a football team for the 1971 season. Sportswriters and fans christened it "The Young Thundering Herd," and amazingly, on September 25, 1971, in the first home game after the crash, the team upset Xavier 15-13. As new coach Jack Lengyel proclaimed after the victory, "No one thought we had a chance to win except the team."

A new student union had long been in the planning stages at Marshall, and construction finally began in 1969. Here a hovering helicopter makes a delivery to the roof of the still-unfinished building on Fifth Avenue. Following the plane crash, the new union was named the Memorial Student Center.

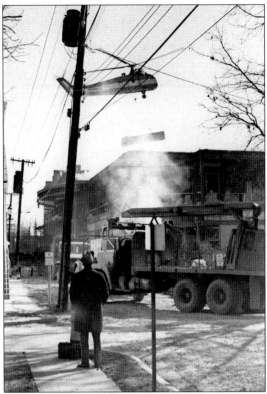

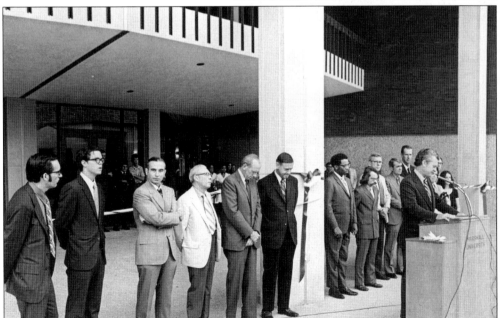

The Memorial Student Center was dedicated in ceremonies conducted September 20, 1971. Included in the building are the university bookstore, a cafeteria, coffee house, bowling alley, billiard room, dining rooms, and various offices. A comfortable lounge is a popular gathering place for students.

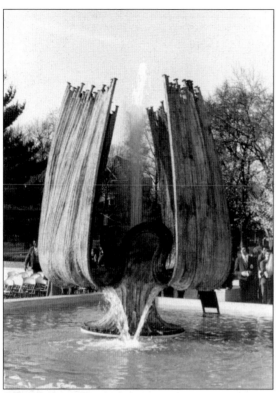

An outdoor plaza on the campus side of the Student Center is the setting for the Memorial Fountain, dedicated to the victims of the 1970 plane crash. Designer Harry Bertoia voiced a hope that the fountain would "commemorate the living—rather than death—[with] the water of life, rising, receding, surging to express upward growth, immortality and eternality."

With the completion of the new Student Center, it was time for old Shawkey Student Union to meet its fate. "I cringed every time that old (wrecking) ball hit the building, as brick and mortar crumbled to dust," said longtime manager Don Morris. "I could see myself and the people I had come to know and love in those old rooms, planning activities or just having a good time."

An aerial photograph taken in the mid-1970s gives a good view of Smith Hall. Third Avenue can be seen at the lower left of the photograph and Sixteenth Street at lower right. Old Main can be glimpsed to the right of Smith Hall at the top of the photograph.

Marshall's Twin Towers dormitories rising on Fifth Avenue dominate this mid-1970s aerial shot. Numerous residences, many of them used for student housing, can be seen along Sixth and Seventh Avenues at the bottom of the photograph. The Ohio River is at the photograph's top.

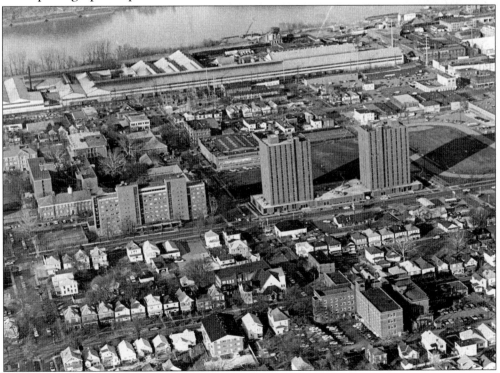

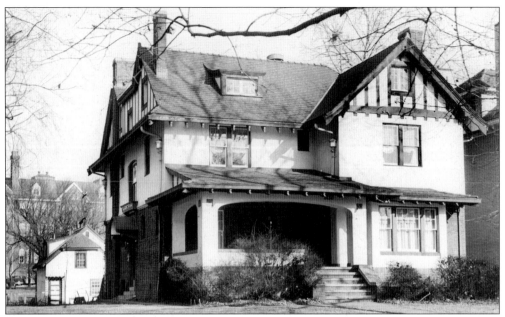

Over the years, Marshall's presidents have lodged in three official homes. This residence, the first permanent home for the president, was purchased for $32,000 in 1925. It was located on the northeast corner of Fifth Avenue and Sixteenth Street, where Corbly Hall now stands.

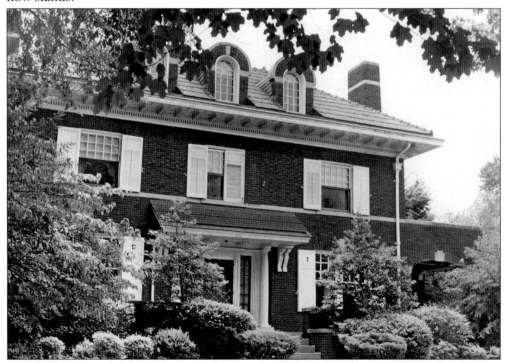

In 1966, the university acquired this larger residence, located in the 1500 block of Fifth Avenue, as its presidential home, but almost immediately, a search was launched for something more stately and more suitable for use as a setting for university functions.

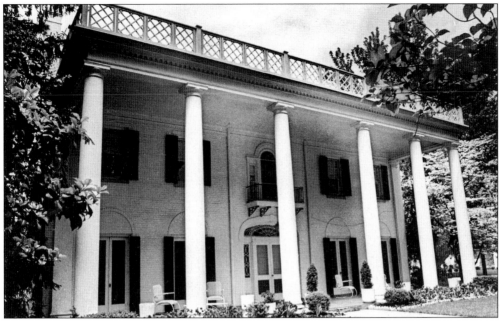

In 1971, the board of regents paid $95,000 for this elegant Colonial home at 1040 Thirteenth Avenue, overlooking Ritter Park, and then spent more than $50,000 on renovating it. Some people criticized the expenditure, arguing it was needlessly extravagant for a university constantly forced to pinch its pennies. President Barker shrugged off that criticism, and he and his family moved in.

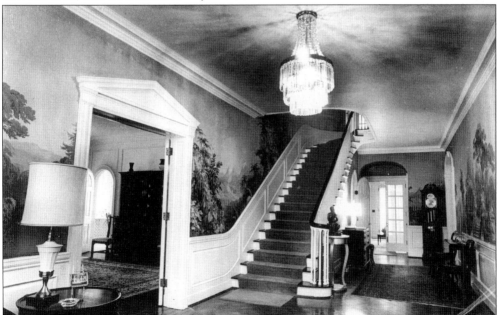

This interior photograph of the Marshall president's official home gives a good view of the imposing entrance hall, dominated by a sweeping stairway and decorated with hand-painted wallpaper. The first floor of the home is used for various university functions, with the second floor set aside for the private use of the presidential family.

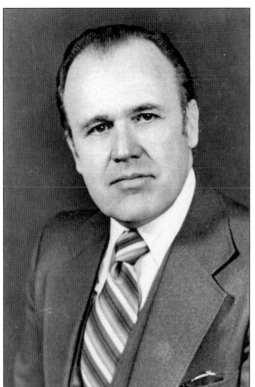

Dean Robert B. Hayes of the Teachers College was named interim Marshall president on July 2, 1974, when President Barker resigned. Four months later, Hayes was made permanent president. Born in Clarksburg, he became the first West Virginia native to serve as Marshall president since Lawrence J. Corbly in 1915.

On the day he was appointed president, the blunt-speaking Hayes—shown here fourth from left at a faculty reception shortly after he took office—commented, "There is nothing wrong with Marshall that creative thinking and hard work cannot cure."

Renovation work at the president's house delayed moving day for President Hayes and family, but on January 8, 1975, the family took up residence. Ruth Hayes is shown here at the house's back door giving directions to mover Roger Chafin.

In 1977, Marshall awarded Jay Rockefeller, then West Virginia governor, an honorary doctor of laws degree. Rockefeller (right) marches alongside President Hayes in this commencement photograph. Rockefeller was elected to the U.S. Senate in 1984.

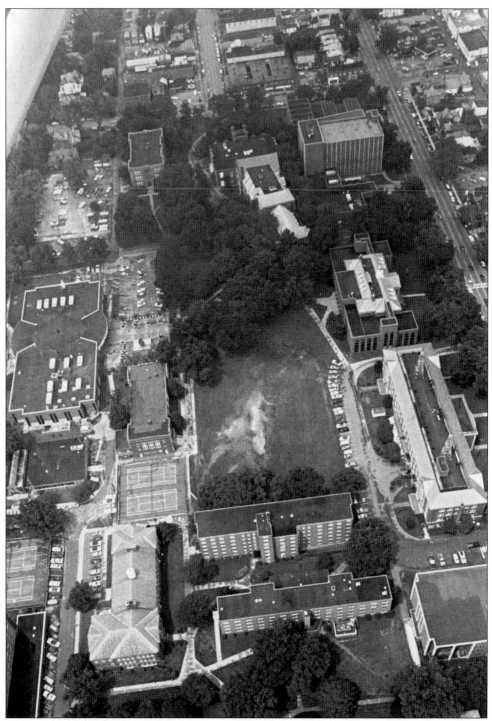

This aerial photograph, taken in the late 1970s, gives a good look at some of the campus growth during that decade. The camera is facing west. In the lower right-hand corner is Harris Hall, a new classroom building erected on the site of the former music building and named in honor of Dr. Arvil E. Harris, the first dean of the Graduate School.

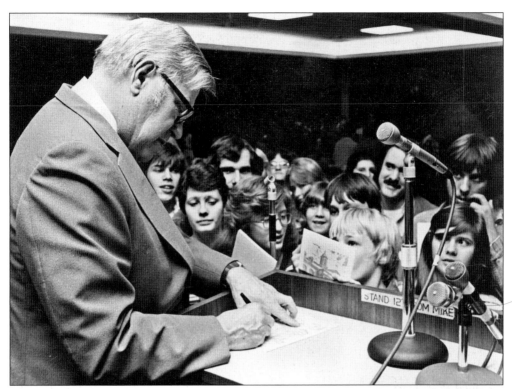

Kentucky's famed Jesse Stuart—novelist, poet, teacher, and living legend—was a frequent visitor to the Marshall campus over the years. On November 19, 1975, officially declared "Jesse Stuart Day" at Marshall, the Kentucky author read from some of his works and obligingly signed autographs for eager students.

A younger Stuart poses for a photograph during a visit to Marshall in the late 1930s, not long after he burst on the literary scene in 1934 with his first book of poetry, *Man with a Bull-Tongue Plow*. Amazingly for the next half century, until his death in 1984, Stuart published on average a book a year.

93

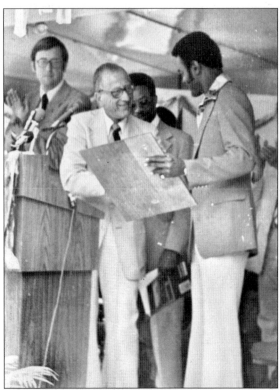

In 1978, Huntington City Council renamed Sixteenth Street Hal Greer Boulevard, honoring the legendary Marshall basketball star who had gone on to a career with the Philadelphia 76ers. Here Mayor Harold Frankel (center) congratulates Greer.

The energetic and emotional Stu Aberdeen, Marshall basketball coach from 1977 until his death from a heart attack in 1979, was enormously popular both on the campus and in the community. Under Aberdeen, the Marshall Memorial Invitational Tournament was discontinued, and after a hiatus of 47 years, an annual basketball game between Marshall and West Virginia University was revived. Aberdeen is pictured at the 1977 contest with WVU.

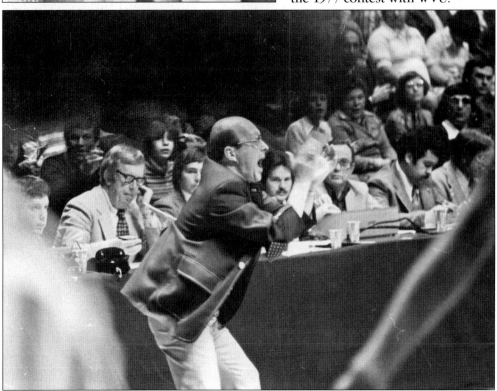

Honorees at Marshall's Alumni Weekend in 1977 pose with President Hayes. From left to right are Distinguished Service Award–winner Mike Maroney, Community Achievement Award–winners Eugene Brown and Charles Lanham, President Hayes, and Distinguished Alumnus Jack Maurice, editor of the *Charleston Daily Mail* (1950–1978) and 1975 winner of the Pulitzer Prize for editorial writing.

NAACP executive director Benjamin Hooks visited Marshall in 1978 to help establish a campus chapter for the organization. From left to right are Marshall associate dean Kenneth Blue, Hooks, and Joe Williams, president of the Huntington Professional and Businessmen's Club.

No individual was more instrumental in making Marshall's medical school dream a reality than U.S. senator Jennings Randolph, shown here during a 1979 visit to the campus. At left is President Hayes, and at right is William C. Campbell, legendary amateur golfer, Huntington businessman, and member of the Marshall Advisory Board.

The 1979–1980 officers of the Marshall Alumni Association included, from left to right, Jack K. Kinzer Jr., treasurer; Mary Dru Ramsey Moehling, second vice president; Philip E. Cline, president; Owen Keith Taylor, first vice president; and Suzanne Showen Walton, secretary.

Seven

YEARS OF GROWTH

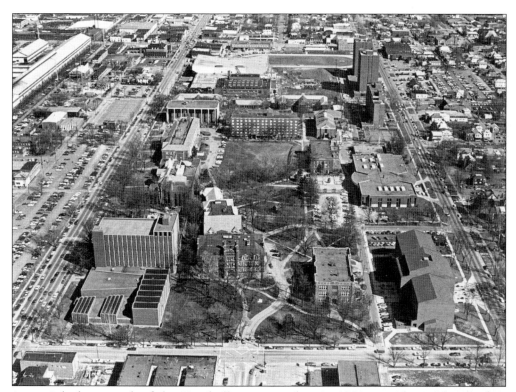

An aerial photograph of the Marshall campus taken in 1981 provides evidence of its growth during the 1960s and 1970s. The camera is facing east, with Hal Greer Boulevard running across the bottom of the photo. Smith Hall can be seen at the lower left and Corbly Hall at lower right.

The longtime dream of a medical school at Marshall came true in the late 1970s, thanks in large measure to federal legislation that provided $16 million in startup funding. In January 1978, the medical school admitted its first class of 20 men and 4 women, all of them West Virginians, save one Kentuckian. From the outset, training West Virginians to be family doctors has been the school's primary mission.

No one person can be credited with making the Marshall medical school a reality, but few worked harder than Dr. Albert Esposito, a Huntington eye doctor. In ceremonies held January 9, 1978, Marshall recognized Esposito's efforts by awarding him an honorary doctor of science degree. Also honored for their efforts on behalf of the medical school were West Virginia businessman Buck Harless and U.S. senator Jennings Randolph (Democrat, West Virginia).

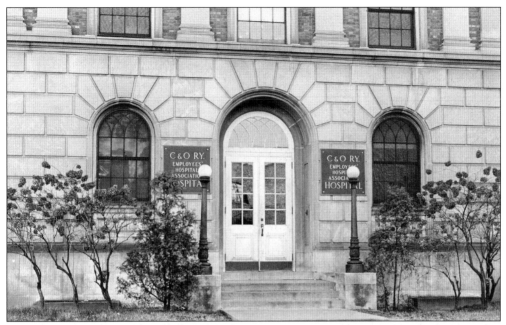

In 1978, the former Chesapeake & Ohio Railway Employee Hospital on Sixth Avenue at Eighteenth Street became the first home of the new Marshall medical school. In 1971, the old hospital had been renamed Doctors' Memorial in memory of three Huntington doctors—H. D. "Pete" Proctor, Ray R. Hagley, and Joseph E. Chambers—who were killed in the 1970 jetliner crash.

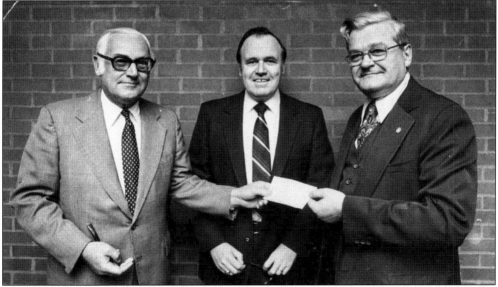

Generous contributions from the private sector also played an important role in establishing the Marshall medical school. This 1980 photograph shows Ashland Oil president Robert Yancey, at left, presenting a check for $100,000 to President Hayes, center, and School of Medicine dean Robert W. Coon. The check was the second installment of a three-year, $300,000 pledge by Ashland. Other early donors to the school included the Gannett Newspaper Foundation, the Benedum Foundation, and Huntington Alloys.

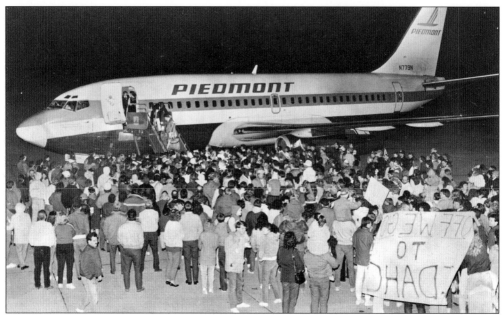

In 1984, Marshall football snapped the nation's longest streak of losing seasons—20 years. On December 12, 1987, Marshall beat Appalachian State 24-10 to win a berth in the NCAA I-AA playoffs. More than 1,000 happy fans were waiting at Tri-State Airport when the plane carrying the team arrived that night. The next Saturday saw the Herd fall to Northeast Louisiana by one point, 43-42.

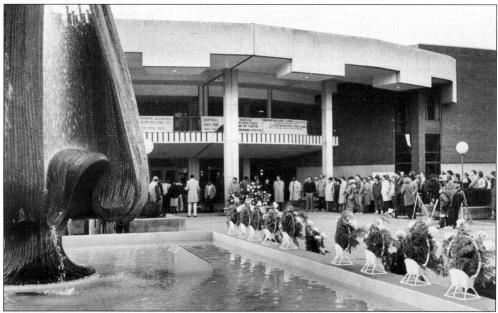

Each year on November 14, campus ceremonies pay tribute to the victims of the 1970 jetliner crash. Here, at 1984's ceremony, green and white wreaths line the Memorial Fountain dedicated to the football players, coaches, and fans killed in the crash. Speaking at the ceremony, Huntington mayor Joe Williams noted that memory can cause pain "but also cleanses the heart and soul and helps put things in perspective."

Shown here under construction, the new $18-million home of Marshall University basketball was, on its completion, christened Henderson Center in tribute to the legendary Cam Henderson. The first varsity basketball game was played at the new center on November 27, 1981, and saw Marshall beat Army 71-53.

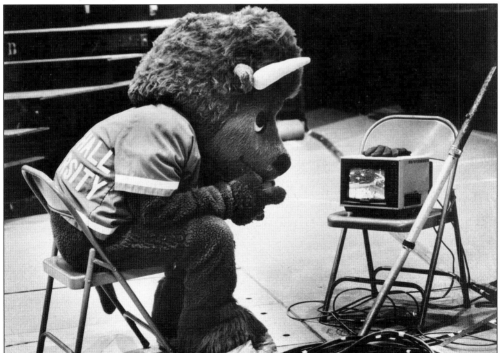

Marco, Marshall's familiar buffalo mascot, works hard patrolling the sidelines during games, trying to keep everybody's enthusiasm high and sometimes providing a few laughs. Even a hard-working mascot has to take a break now and then.

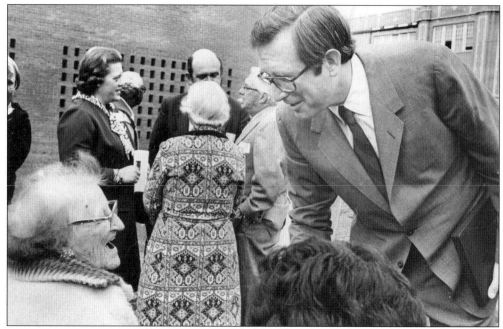

Speaking on October 4, 1980, at dedication ceremonies for Corbly Hall, Gov. Jay Rockefeller described it as "the largest and most modern classroom building in the state of West Virginia." The building is named for Lawrence J. Corbly, who served as Marshall president from 1896 to 1915. Rockefeller is pictured as he talks with Mamie Spangler, who said she studied under Corbly.

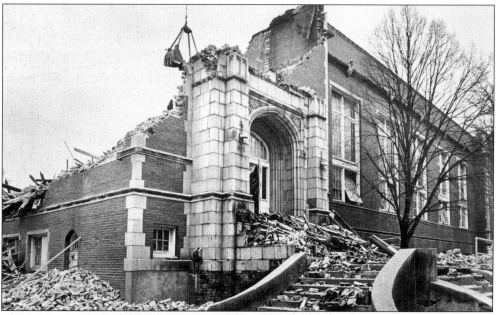

With the completion of Henderson Center, Marshall no longer had need of the old women's gym, and a wrecking crew made short work of it. This photograph was taken December 20, 1982. When Marshall students returned from their Christmas break that year, they found the old building gone.

Dale F. Nitzschke arrived on the Marshall campus in March 1984 from Nevada to become Marshall's 11th president, succeeding President Hayes. He served for six years, resigning in 1990 to become president at the University of New Hampshire.

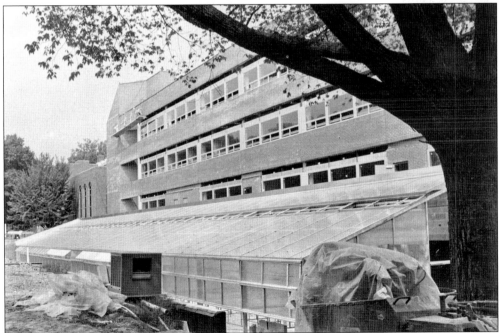

Marshall finally completed a badly needed—and long-delayed—addition to the Science Hall in 1983. The addition, erected on the south or campus side, all but dwarfs the original building.

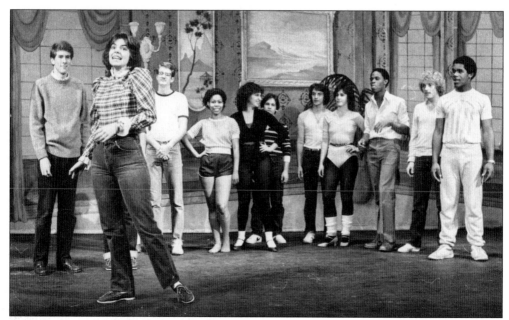

In November 1982, Marshall University Theatre staged *Funny Girl*, the musical comedy based on the life of comedian Fanny Brice. The original Broadway production launched the career of singer Barbra Streisand. The Marshall production featured elaborate costumes and sets that once would have been unthinkable for a campus production.

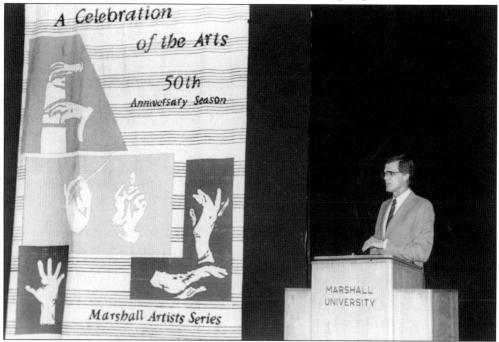

President Smith once described the Marshall Artists Series as "a success story of community-college cooperation that has aroused the envy and admiration of many other colleges." In 1987, that success story marked its 50th anniversary with a gala celebration. President Nitzschke is shown at the podium.

When J. D. Folsum came to the Marshall faculty in 1968, Marshall had no classes in jazz. Folsum quickly set about changing that. He not only helped introduce jazz to the curriculum, he organized a jazz band and even a jazz festival. He is shown here at the 19th annual Marshall Jazz Festival in 1988.

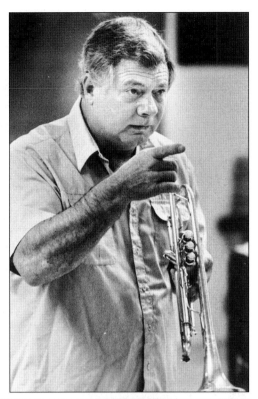

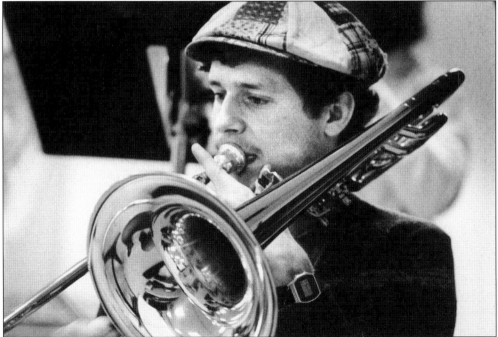

Kirk Hickle, a member of the Marshall University Jazz Ensemble, plays at the 1988 Jazz Festival. Today Marshall's jazz program is housed in the $2.6-million Jomie Jazz Center, one of several generous gifts to the school from Joan and James Edwards.

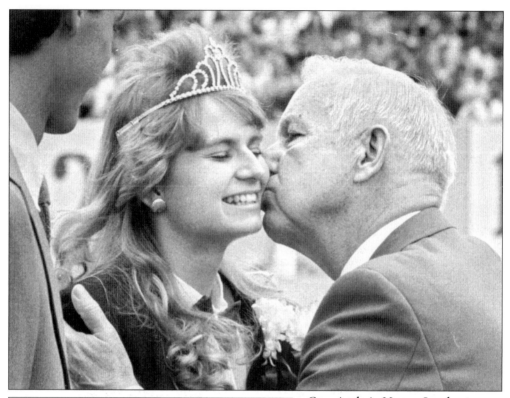

Gov. Arch A. Moore Jr. plants a big kiss on Marshall's 1985 homecoming queen, Lorie Wyant. Half-time ceremonies at the game saw President Nitzschke present Moore with a traditional green Marshall blazer. "It looks great. It goes with my eyes," quipped Moore.

Sheryl P. Coles (second from right), a marketing major from Charleston, was Marshall's 1987 homecoming queen. At far right is senior attendant Rebecca Lynn Michael of Paden City. At far left is sophomore attendant Paula Nichole Peet of Winfield. Debbie Lynn Carter of Beckley was junior attendant. The game saw Marshall roll to an easy victory over East Tennessee, 27-7.

The bleachers at Henderson Center were put to an unusual use in September 1986, when members of Marshall's ROTC Ranger Company used them to practice their rappelling skills. In 1934, the faculty had voted overwhelmingly against the installation of a military science program on the campus, but World War II erased that attitude, and at the war's end, Marshall immediately began efforts to add a ROTC program. Those efforts were successful in 1951. Though originally an ordinance unit, the army soon (in 1954) changed the program to a general military science curriculum.

International students have long been a familiar part of the campus scene at Marshall. Visitors to this 1985 celebration, sponsored by the Marshall International Relations Club, had an opportunity to taste a wide variety of foreign foods and sample a number of different cultures.

Veteran Marshall faculty member Sam Clagg cuts the cake at the 1987 celebration of Marshall's 150th birthday. Co-captain of Marshall's 1942 football team and later an assistant football coach, Clagg was a member of Marshall's Department of Geography from 1948 until his retirement in 1986. He served a stint as Marshall's acting president and has published a dozen books, including *The Cam Henderson Story—His Life and Times*.

Members of Marshall's 1983–1984 band put in some practice before football season gets underway. Ben Miller, associate professor of music, sports a "rock 'n roll" t-shirt as he puts the drum section through its paces.

Marshall's majorettes strut their stuff at old Fairfield Stadium in the fall of 1990.

Marvin L. Stone (left), editor of *U.S. News & World Report* from 1976 to 1985, was a proud Marshall journalism graduate (class of 1948). Stone died in 2000 at age 76 at his home in Falls Church, Virginia. He is pictured during a 1987 visit to the campus. Seated with him is Deryl Leaming, who was then chairman of the journalism department. Leaming later served as dean of the College of Liberal Arts.

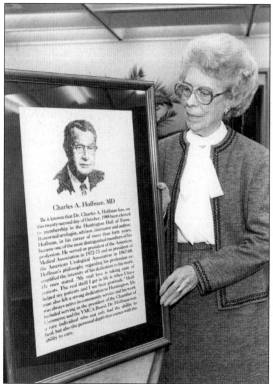

The personal and professional papers of the late Dr. Charles "Carl" Hoffman, a Huntington urologist who served as president of the American Medical Association in 1972–1973, are housed in the Hoffman Room of the Marshall Library. Over the years, Dr. Hoffman, who died in 1981, was a generous contributor to the library. His widow, Margaret Lynn Hoffman, is shown here with the citation for his induction into the Huntington Wall of Fame.

On October 14, 1947, Lincoln County native Charles E. "Chuck" Yeager made aviation history when he became the first man to fly faster than the speed of sound. In 1969, Marshall presented General Yeager an honorary degree. Later he agreed to have his name used for Marshall's Society of Yeager Scholars, a scholarship program for talented youngsters. Here he poses with 1987's class of Yeager Scholars.

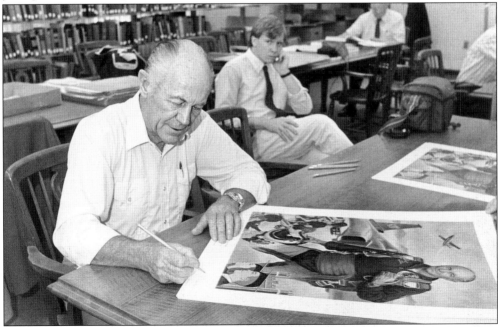

Over the years, Yeager has been a frequent visitor to the Marshall campus, addressing classes and informally meeting with students. He is shown autographing a poster during a visit in 1989. Many of the trophies, awards, and other mementos of the famed airman's long career are housed in the Marshall Library's Yeager Room.

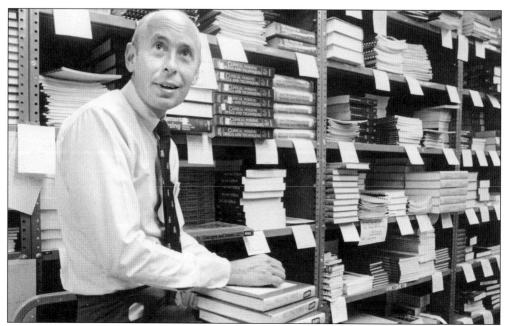

Long a familiar figure at the Marshall University bookstore, Joe Vance poses for a 1989 photograph with just a few of the countless textbooks the store must stock each semester. Marshall's first bookstore was located on the third floor of Old Main. In the late 1920s, the store was moved to the basement. In 1972, it was moved to the Memorial Student Center.

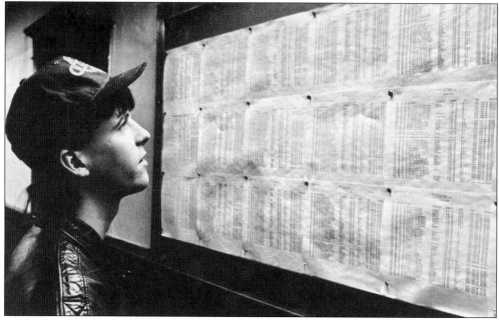

With a growing student body and a shrinking faculty, the result can often be a long list of closed classes and a lot of frustrated students. That was clearly the case in 1990, as Marshall sophomore Gordon Jobe tries to find a class he needs to finish his schedule. The computer printouts posted on the wall are lists of closed classes.

Eight

INTO THE 21ST CENTURY

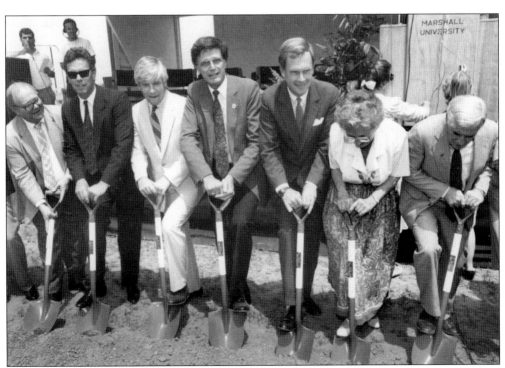

In 1989, after years of controversy and delay, Marshall finally broke ground for a new football stadium to replace venerable Fairfield, the home of Marshall football since 1928. President Nitzschke is at the center of this shovel-wielding line, with various legislators and other dignitaries arrayed on either side of him.

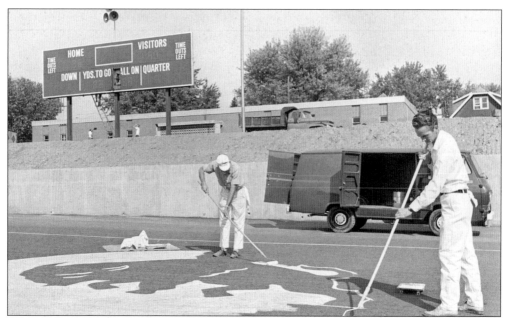

Until 1970, Marshall, the Cabell County Board of Education, and the Huntington Park Board jointly owned Fairfield Stadium. With nobody solely in charge, maintenance went neglected and the stadium was allowed to deteriorate. Marshall voiced a willingness to upgrade Fairfield but only if it became sole owner. The school system and the park board gladly agreed. In this 1981 photo, Marshall's Floyd McSweeney and Truman Collins apply some preseason paint to Fairfield's AstroTurf.

In revamping Fairfield, Marshall made room for 6,800 more seats by lowering the playing field. Even so, the old stadium continued to show its age. In 1984, an inspection deemed that the east-side stands were in danger of collapsing, so the upper level of the stands was demolished and replaced with new bleacher-type seating.

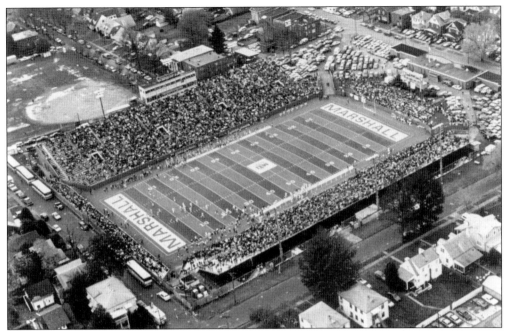

Marshall played its last game at Fairfield before a crowd of 16,000 fans on November 10, 1990. In departing Fairfield, the Thundering Herd left behind one of the poorest stadiums in college football, but the school also left some splendid memories there.

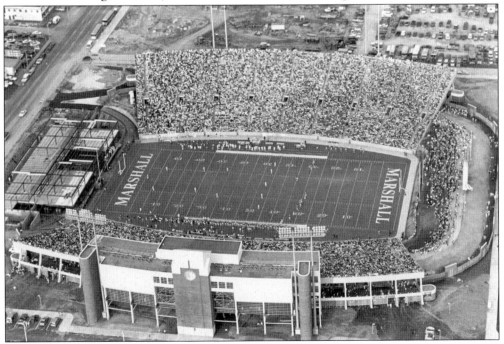

A decades-long dream became a reality in 1991, when Marshall opened its new $30-million football stadium at Twentieth Street and Third Avenue, just east of the campus. With 28,000 seats, the stadium attracted a standing-room-only crowd of 33,116 fans for the September 7 opener, which saw the Herd edge the University of New Hampshire 24-23.

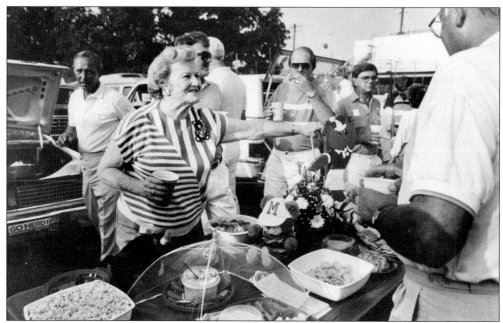

Tailgating has always been popular at Marshall football games, but with the opening of the new stadium, Herd fans have developed it into a high art. Here, veteran Marshall tailgater Lois O'Shea tells a hungry friend to help himself. The groaning table seems to offer plenty for him to choose from.

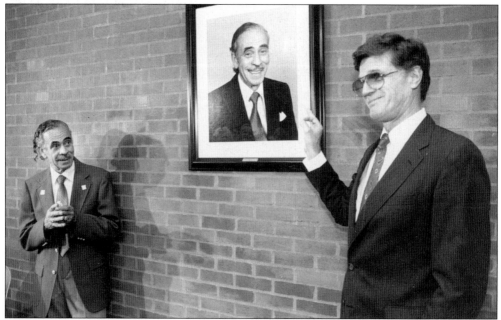

Schools often name things for generous donors or veteran faculty members. In 1990, President Nitzschke gave the name game a new twist when he named a Memorial Student Center dining room for the well-liked John Spotts, a longtime member of Marshall's food service staff. Spotts retired in 1993, ending a 40-year career with Marshall. His retirement party was held in—where else?—the Spotts Dining Room.

Yes, that is Soupy Sales in cap and gown at Marshall's 1990 commencement, where he was presented an honorary degree. Soupy—nobody calls him "Mr. Sales"— grew up in Huntington and majored in journalism at Marshall, graduating in 1949. He got his start as a Huntington disc jockey, going on to become a comic legend.

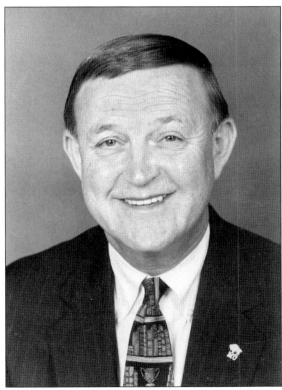

J. Wade Gilley was appointed Marshall president in 1991, succeeding President Nitzschke, who left Marshall to be president of the University of New Hampshire. Gilley came to Marshall from George Mason University in Fairfax, Virginia, where he was senior vice president. He resigned as Marshall president in 1999 to take the presidency of the University of Tennessee in Knoxville.

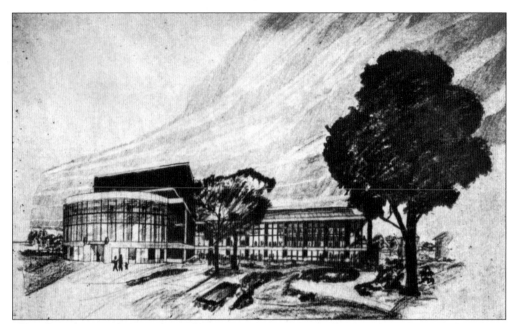

When the Joan C. Edwards Performing Arts Center, named to honor the Huntington philanthropist and patroness of the arts, was opened in 1992, it marked the end of a planning process that stretched back for more than a decade. Here is a preliminary architect's sketch that was released to the media in 1986.

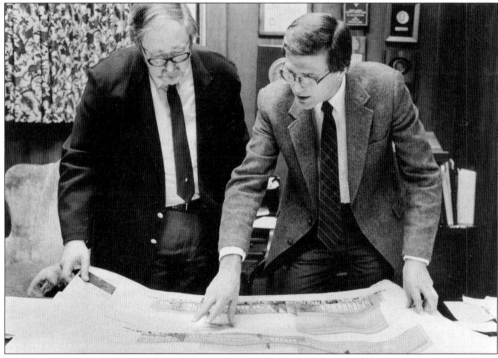

Dean Paul A. Balshaw of the College of Fine Arts, left, and President Nitzschke look over blueprints for the proposed arts center. Nitzschke would leave Marshall before the building became a reality.

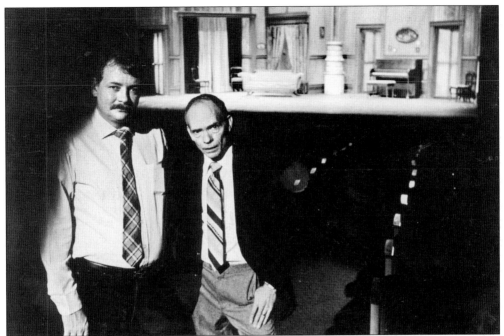

In a 1986 photograph, Auditoria manager Bruce Greenwood, left, and N. B. East, chairman of the Marshall Department of Theater/Dance, are shown in venerable Old Main auditorium, a facility that long since had outlived its usefulness.

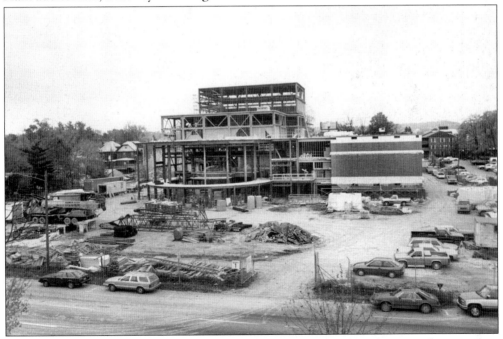

Construction of the arts center was well underway when this photograph was taken in the fall of 1990. Located on the south side of the campus, just across Fifth Avenue from the Memorial Student Center, the center includes a 530-seat auditorium, a smaller experimental theater, rehearsal rooms, and a set-building shop.

This architectural drawing may puzzle many familiar with the Marshall campus. It shows the familiar front of Old Main at left and, to the right, a look-alike structure that was never built. This was one of several preliminary proposals considered when the university began planning for a new library.

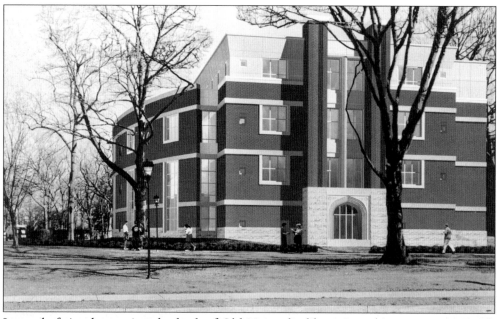

Instead of simply copying the look of Old Main, the library's architects came up with a design that, while modern, nonetheless complements the campus landmark that it neighbors. The $29-million John Deaver Drinko Library is named for a 1942 Marshall graduate who is senior managing partner of Baker and Hostetler, one of the nation's largest law firms. He and his wife, Elizabeth Gibson Drinko, have been longtime significant supporters of academic programs at Marshall.

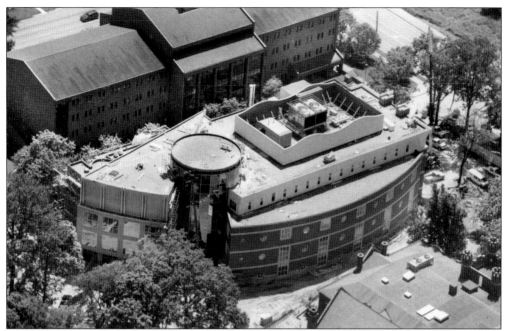

Northcott Hall, the second-oldest building on the Marshall campus, was demolished to make way for the new Drinko Library, shown here in a 1998 aerial view as its construction neared completion. Corbly Hall can be seen behind the library at the photograph's top left.

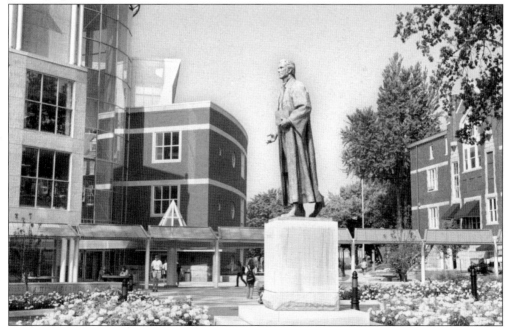

Between the Drinko Library and Old Main stands a handsome bronze statue of John Marshall, created by sculptor William Behrends of Tryon, North Carolina, and unveiled October 23, 1998. On the base of the imposing statute are engraved the words "Revolutionary soldier, Defender of the Constitution. Devoted husband and father."

Construction of the Drinko Library seemed an appropriate time to do some long-overdue renovations at Old Main to guarantee that it can continue to serve the school for many more years. Here a spiderweb of scaffolding can be seen wrapped around the old building's familiar towers.

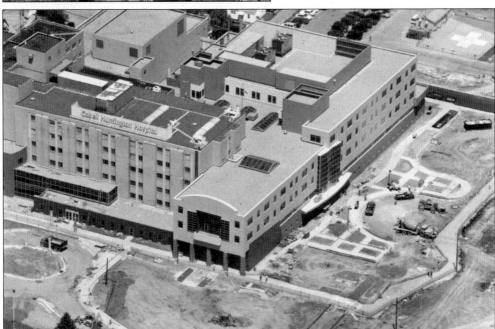

The $31.9-million Marshall Medical Center, shown under construction, is located adjacent to Cabell Huntington Hospital on Hal Greer Boulevard south of the campus. Opened in 1998, the center brought together elements of the John C. Edwards School of Medicine that had been scattered in buildings throughout Huntington.

Dan Angel, who previously was president of colleges and universities in California and Texas and was elected to three two-years terms in the Michigan legislature, became Marshall's president in 2000, succeeding President Gilley. Angel retired at the end of 2004, ending what he characterized as 32 years of "high octane" public service.

Originally established in the former Athletics Facility Building at Fairfield Stadium and expanded with an addition in 2004, Marshall's Forensic Science Center houses a program that is a nationally recognized leader in this important area of support for law enforcement. Marshall has a unique relationship with the West Virginia State Police as the first university to partner with a state crime laboratory on developing and maintaining a DNA database of convicted offenders.

Three of the most familiar faces in Marshall football history pose for the camera. Bob Pruett not only took Marshall to an undefeated season and national championship in his first year as head coach, he elevated Marshall from NCAA Division I-AA to the big-time ranks of Division I-A and, in the process, earned well-deserved national recognition as "the winningest coach in college football." The Herd's winning ways also launched the successful NFL careers of Randy Moss, left, and Chad Pennington, right.

On November 28, 2003, Marshall honored Joan C. Edwards for her devotion and generosity to the school and community by naming the Herd's football stadium in her honor. Mrs. Edwards is shown here with Coach Pruett. The stadium is the only one in NCAA Division I-A to be named for a woman. Similarly, Marshall's Joan C. Edwards School of Medicine is the nation's only medical school named for a woman.

Some of the "bling bling" Pruett acquired during his nine years as head coach at Marshall is pictured here. Pruett led the Herd to unparalleled success on entering Division I-A, winning five Mid-American Conference championships and five bowls and consistently cracking the Top 25. He stunned Marshall fans with his announcement in March 2005 that he was retiring in order to spend more time with his family and friends. "It's time," he said.

Mark Snyder meets the media after the April 14, 2005, announcement of his hiring as Marshall's head football coach, succeeding the departing Bob Pruett. An Ironton, Ohio, native and 1988 Marshall grad, Snyder spent four years as an assistant coach under Jim Tressel at Ohio State University. During that four-year period, the Buckeyes posted a 40-11 overall record and tallied a 3-1 record in bowl games.

Marshall and West Virginia University will resume their football rivalry with a seven-game series starting in 2006 under an agreement reached by Marshall interim president Michael J. Farrell, left, and WVU president David Hardesty. Gov. Joe Manchin helped broker the agreement, signed May 17, 2005. Manchin labeled the signing "an unprecedented day in West Virginia sports history."

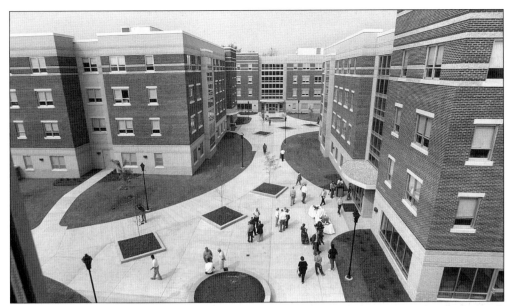

Marshall Commons, located on the north side of Sixth Avenue between Seventeenth and Eighteenth Streets, opened in the fall of 2003. The new complex consists of four suite-style residence halls—Gibson, Wellman, Haymaker, and Willis—and a cafeteria, the Harless Dining Hall. Marshall Commons was the first campus residence hall complex in the nation to offer cellular telephone service to its residents.

Gov. Joe Manchin speaks from the shop floor of the Robert C. Byrd Institute for Advanced Flexible Manufacturing (RCBI) at Marshall in South Charleston. Established in 1990, RCBI offers access to computer-controlled production equipment; affordable, hands-on, technical training; quality management systems improvement assistance and business development; and online networking resources. RCBI's mission is to enhance a capable, quality-oriented supplier base for the Department of Defense, NASA, and commercial markets.

In June 2005, Stephen J. Kopp, special assistant to the chancellor with the Ohio Board of Regents and former provost of Ohio University, was named Marshall president, replacing Michael J. Farrell, who had served as interim president since January 1. Kopp earned a bachelor of science degree in biology in 1973 from the University of Notre Dame and his doctorate in physiology and biophysics in 1976 from the University of Illinois at Chicago.

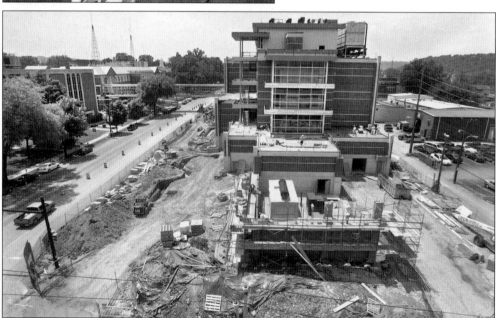

Marshall's new $40-million Robert C. Byrd Biotechnology Science Center is under construction, with its completion expected in 2006. The new center is going up on the north side of Third Avenue, across from the Science Hall and adjacent to Marshall's parking garage. Like the garage, the center will be linked to the campus by an elevated walkway across Third Avenue.